CORNWALL IN PHOTOGRAPHS

GABRIEL FUCHS

AMBERLEY

ACKNOWLEDGEMENTS

And the thanks go to...
The persons who have accompanied me on my photography tours in Cornwall and also helped me review my photos. To François, a big thank you for having been a great buddy for quite a few years now. And to Joel, a big thank you for having been a great buddy for even longer.

But the biggest thanks goes to my wife, Sylvie, who has the patience to constantly review my photos, gives the support I need so that I can take off on weekends as often as I want, and offers a warm welcome when getting back. Photography becomes so much more fun this way.

First published 2017

Amberley Publishing
The Hill, Stroud
Gloucestershire, GL5 4EP

www.amberley-books.com

Copyright © Gabriel Fuchs, 2017

The right of Gabriel Fuchs to be identified as the Author of this work has been asserted in accordance with the Copyrights, Designs and Patents Act 1988.

ISBN 978 1 4456 7124 6 (print)
ISBN 978 1 4456 7125 3 (ebook)

British Library Cataloguing in Publication Data.
A catalogue record for this book is available from the British Library.

Origination by Amberley Publishing.
Printed in the UK.

CONTENTS

Porthcothan

INTRODUCTION

So what's so special about Cornwall? Few places in Europe are as awe-inspiring. It is an ancient Celtic land and as such has inspired tales and legends ever since. It has a dramatic nature with treacherous cliffs, sandy beaches, and mysterious moors. It was a gateway to the rest of the world when the English ruled the waves, and a mining centre during the Industrial Revolution, which very much lay the foundation of what we now call western modernity. Today it is the sum of its history, with a foot left in what it used to be.

Cornwall is indeed a peculiar place on the far south-western fringes of Great Britain. It has a relatively small population of around 550,000 and it has only one officially designated city, Truro. Yet, Cornwall has the largest collection of plant species in the British Isles and its coasts boast more varieties of fish than anywhere else in the UK.

Cornwall is also one of only two royal duchies in England. The Duchy of Cornwall was created in 1337 and its purpose is to provide an income to the heir apparent to the throne. As such, Cornwall can be regarded as the mother of all trust funds.

Considered to be one of the six Celtic nations, Cornwall offers a culture that remains somewhat different from the rest of England. Being out in a corner of Great Britain and with a distinct geography, Cornwall possesses a combination of a rough coastline, barren moors, and plenty of gardens in between. All of these factors make Cornwall distinctly different not only from the rest of the UK, but from the rest of the world.

Furthermore, the weather is changeable even by British standards and it is perfectly possible to have pouring rain, clear blue sky, and then pouring rain again, all within an hour. This means that forecasting the weather is actually not much of a problem; just look out the window. A Cornish weather forecast is rarely more precise than what you see with your own eyes.

No matter what the weather, having the longest coastline in Great Britain, Cornwall tends to be windy. As the wind usually comes from the Atlantic in the west, it is striking to see how trees are leaning to the east, being pushed by these winds. If one gets lost in Cornwall it is possible to navigate just by looking at the trees.

Given its harsh and unique nature, Cornwall remains an inspiration for painters and writers alike. Many tales and legends have taken place in Cornwall, including the mystical King Arthur and the sunken country of Lyonesse from where Tristan came. There are also a great deal of crime stories in Cornwall, which is ironic given that there are no prisons – the last one closed in 1922.

The combination of a splendidly desolate landscape, a rich fauna, some magnificent beaches, and trees leaning to the east – this prohibiting anyone from getting really lost – attracts tourists of all kinds. There are the families, the hikers, the sea-sport enthusiasts, the birdwatchers, the photographers, the artists and the writers. All are kept at an even pace, thanks to the narrow and winding roads that rarely allow anyone to get anywhere too quickly.

The photos in this book represent a bit of everything that Cornwall has to offer in terms of nature, activities, and beauty. Not all photos are sunny and with a blue sky because it does rain in Cornwall too. However, few things can be as moody and impressive as a good rainstorm when the waves come crushing in on desolate rocks. This combination of sun, rain, and wind is, to many, what really makes Cornwall stand out. And stand out it does!

THE NORTHERN COAST OF CORNWALL

Though any part of Cornwall is certainly worth seeing, its northern coast distinguishes itself with barren rock formations mixed with sandy beaches. It is appreciated both by tourists wishing to do anything from hiking to enjoying the sea, and photographers aiming to capture unique cliffs rising from the water.

The northern coast of Cornwall stretches from north of the town of Bude to south of Newquay. In between, it is possible to enjoy anything from serious surfing and visiting excellent restaurants – especially in the town of Padstow, which is known as a culinary hotspot – to admiring some of the most spectacular coastlines in the world. This part of Cornwall, even though rich in activities, also offers much space for relaxation and contemplation.

Storms should not be underestimated and caution should be taken when they arrive, yet poor weather is also worth experiencing on this coast. Few things can be such a reminder of what Mother Nature really is and what seafarers in this part of the world went through. It is also a reminder that Cornwall is worth experiencing at any time of the year.

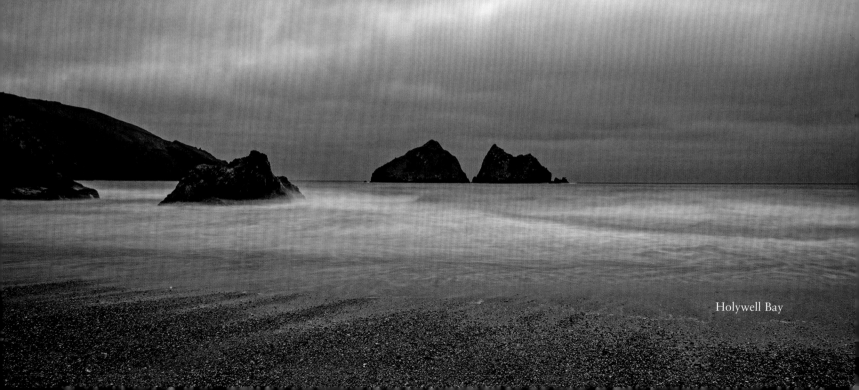

Holywell Bay

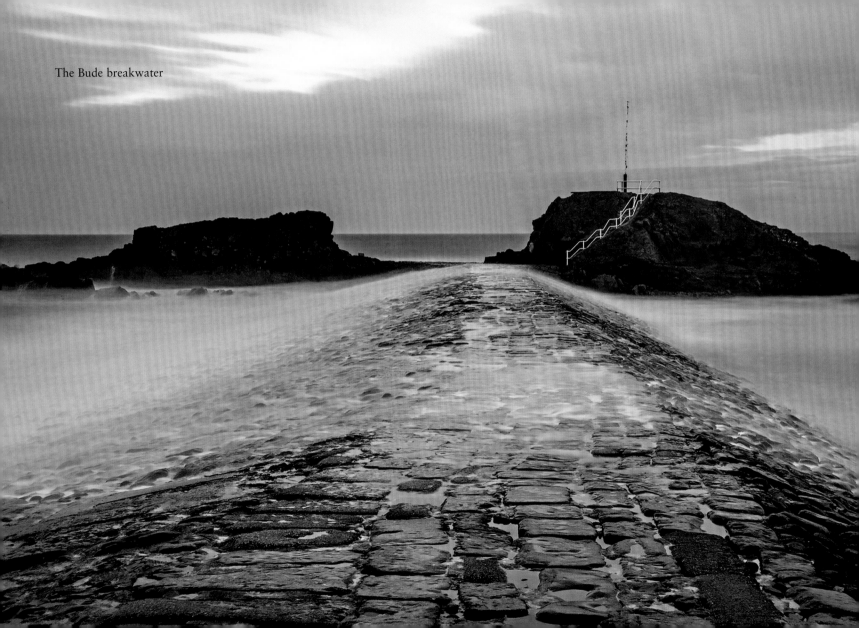

The Bude breakwater

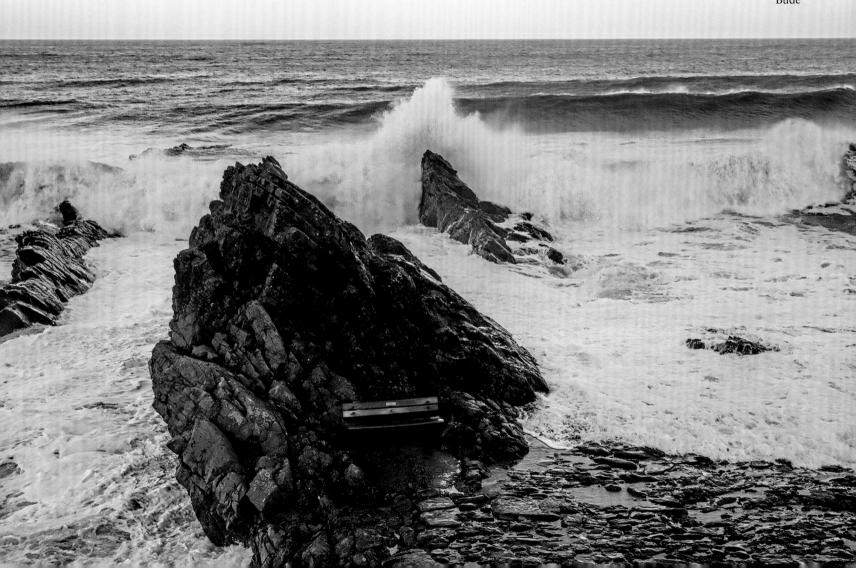

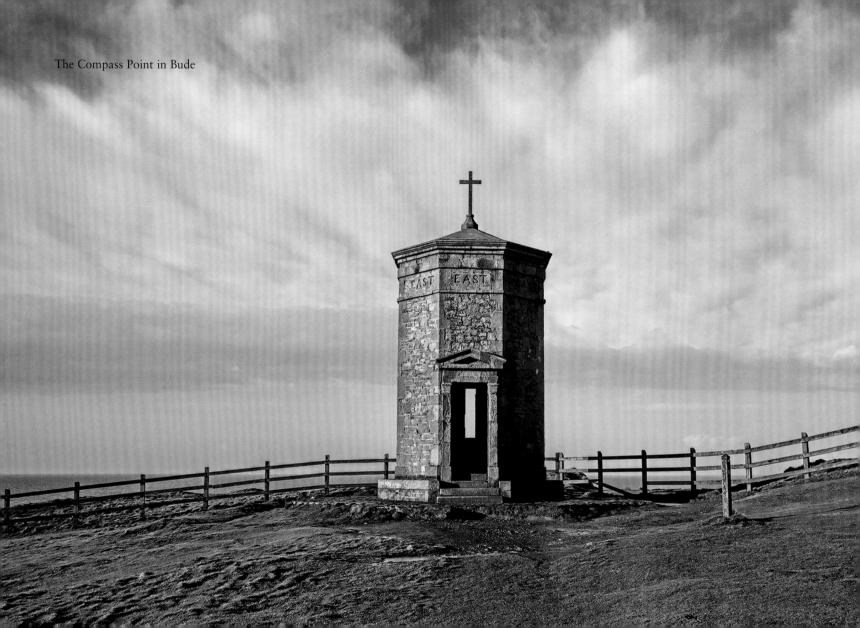

The Compass Point in Bude

Bude

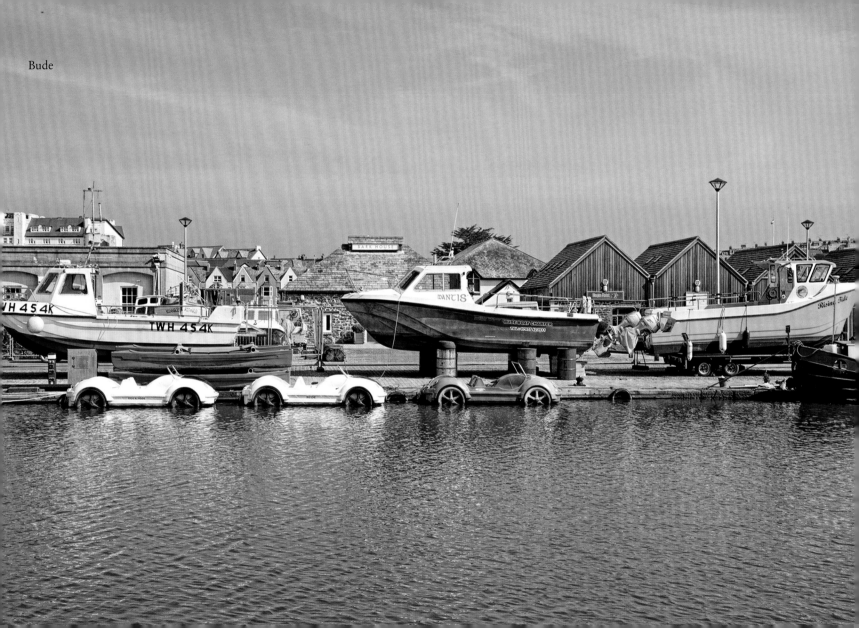

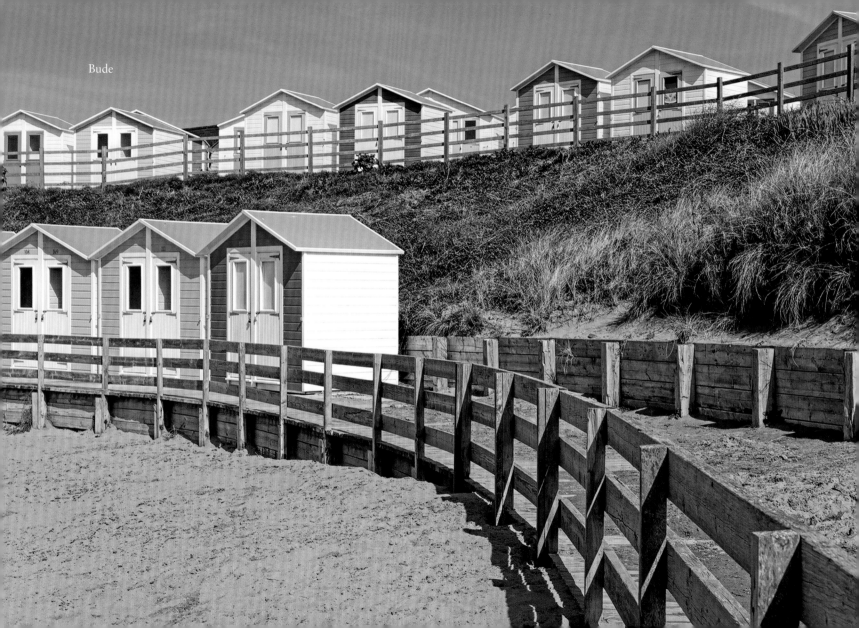

Bude

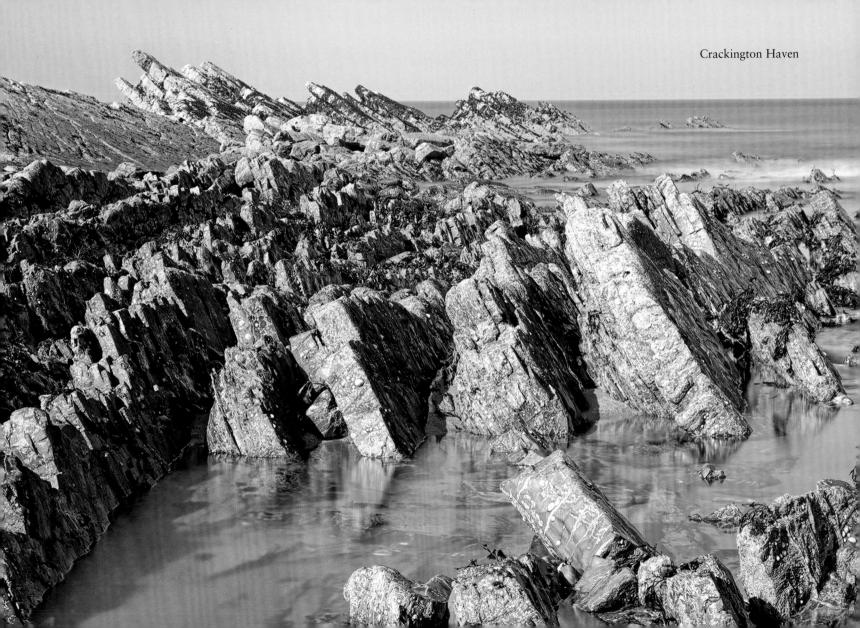

Crackington Haven

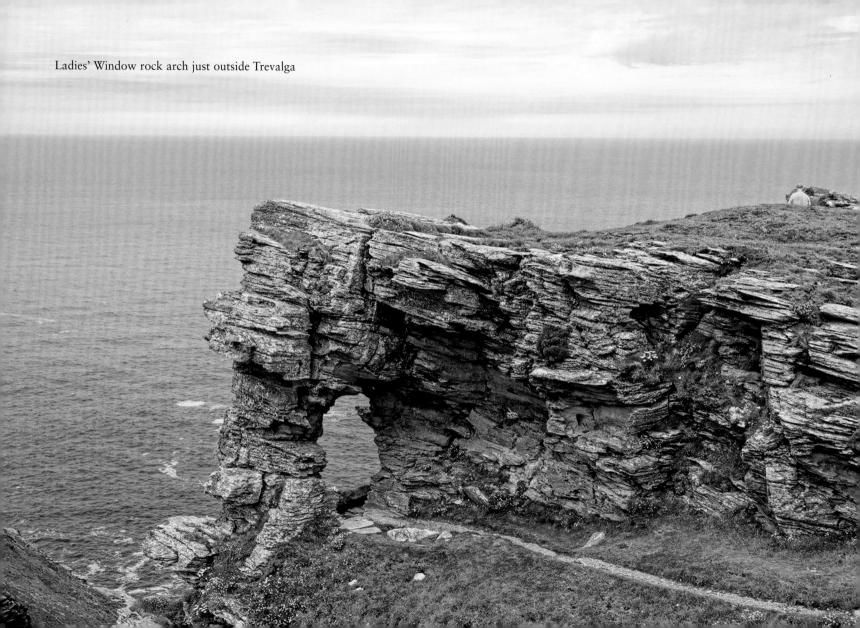

Ladies' Window rock arch just outside Trevalga

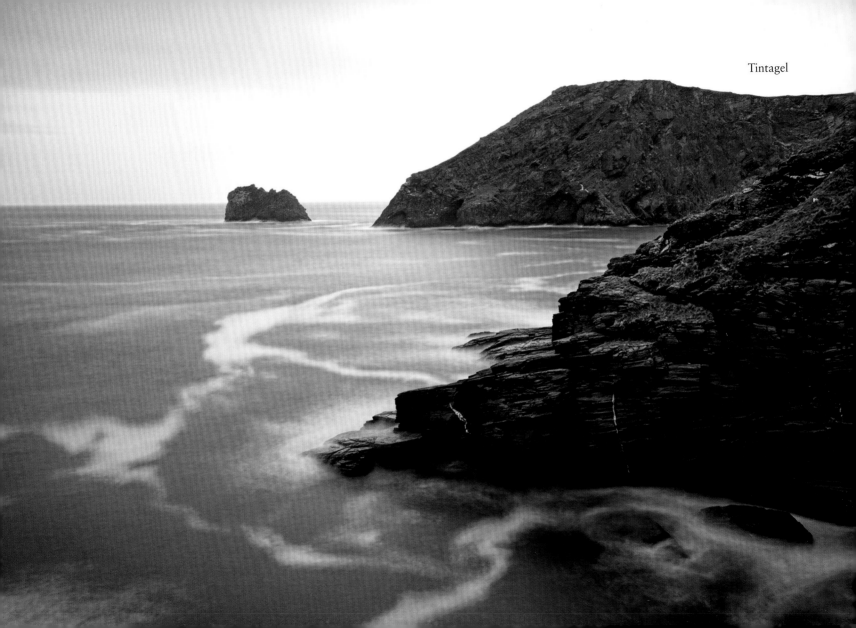

Tintagel

Tintagel

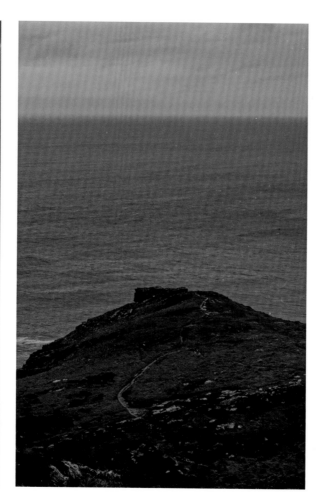

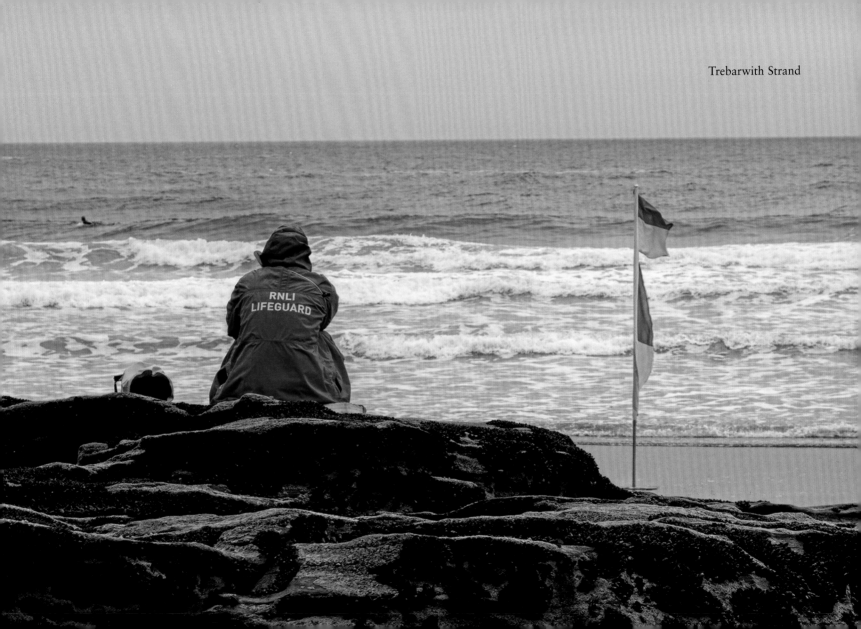

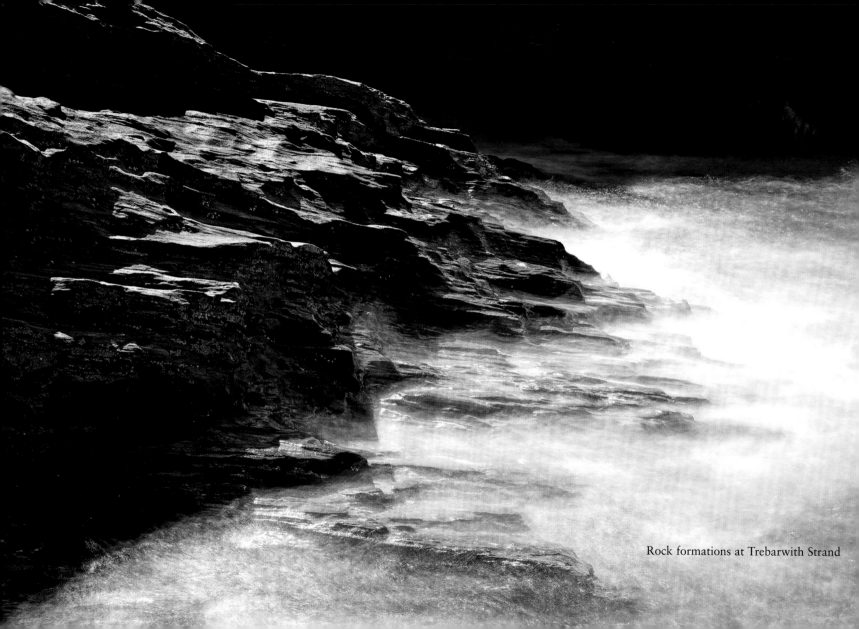

Rock formations at Trebarwith Strand

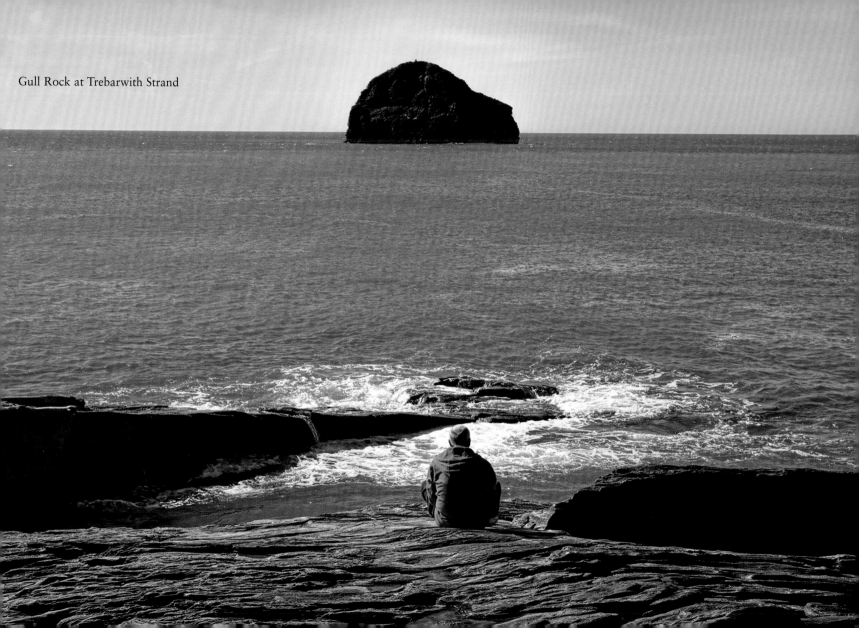

Gull Rock at Trebarwith Strand

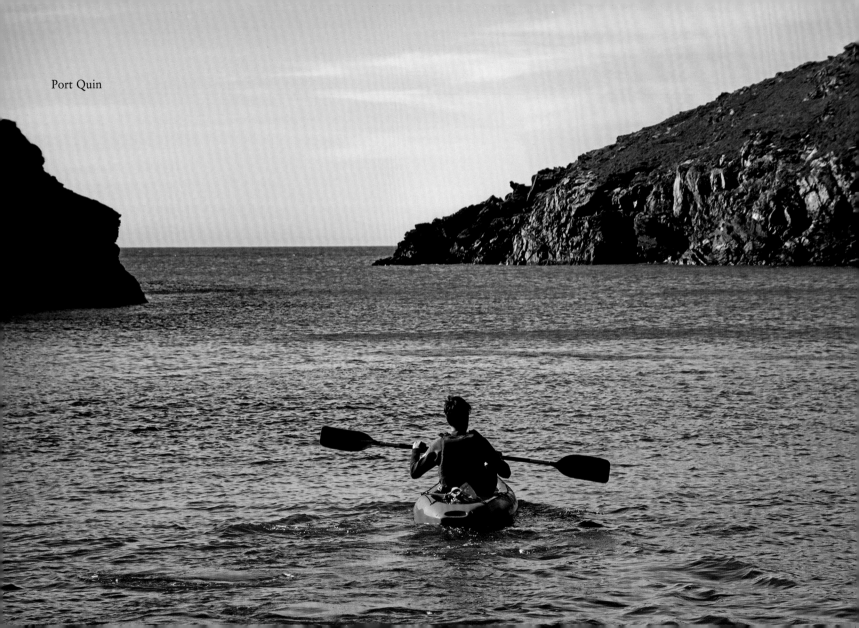

Port Quin

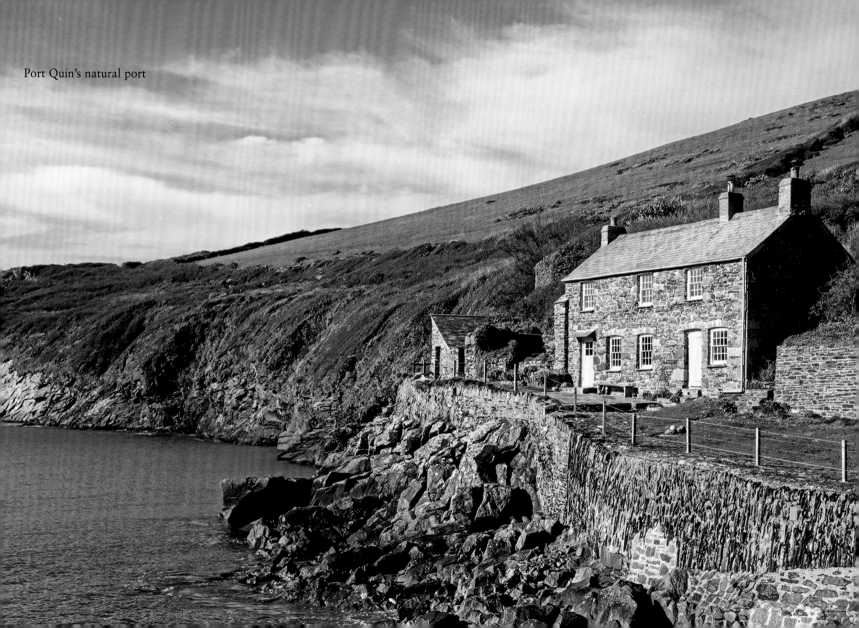

Port Quin's natural port

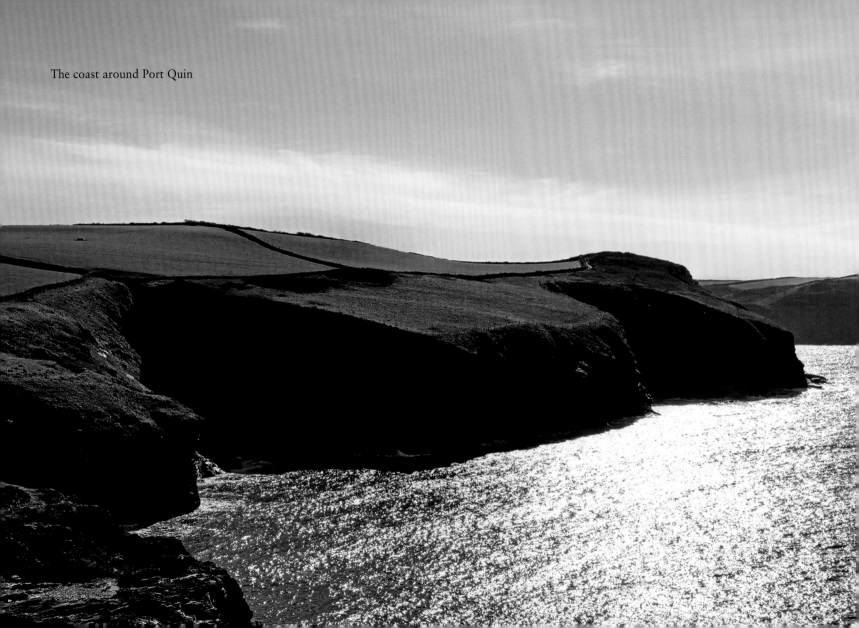

The coast around Port Quin

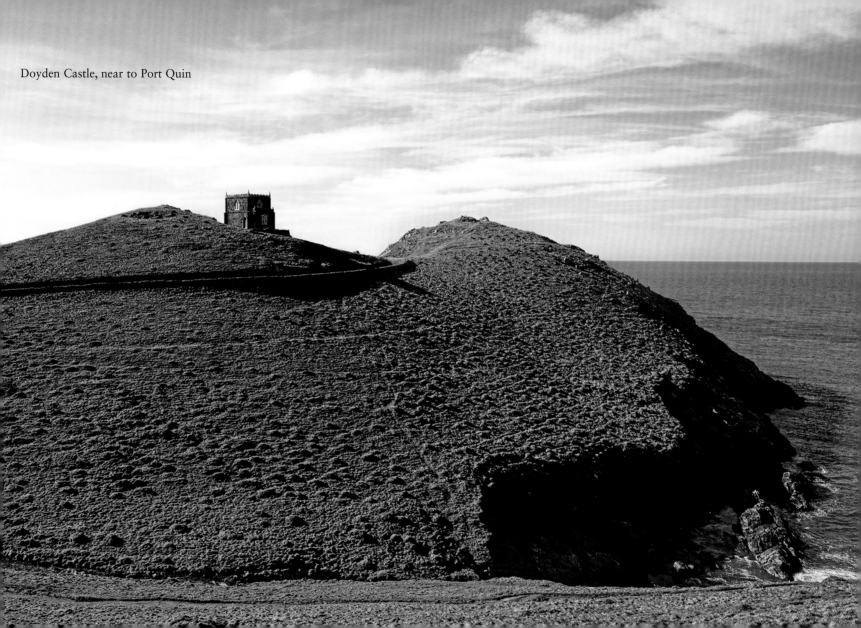

Doyden Castle, near to Port Quin

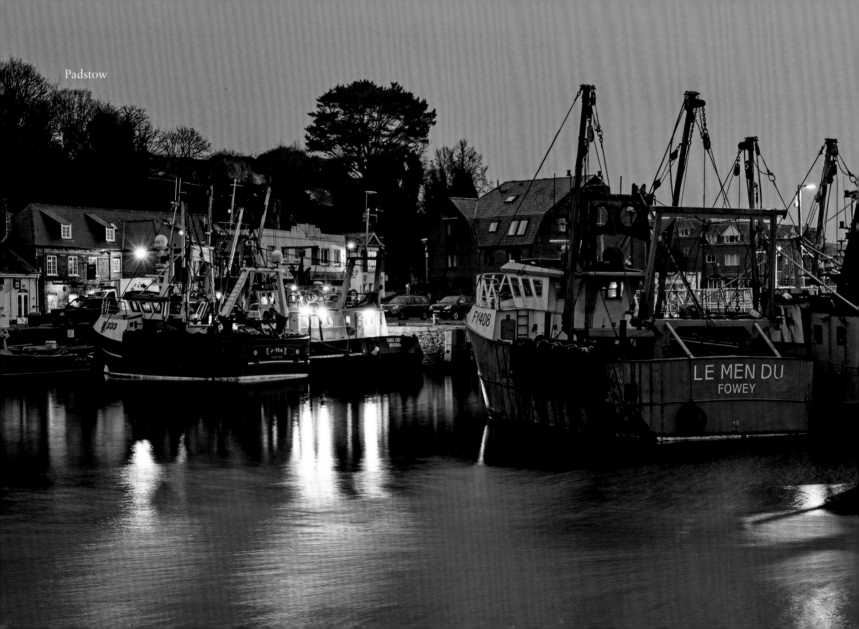

Padstow

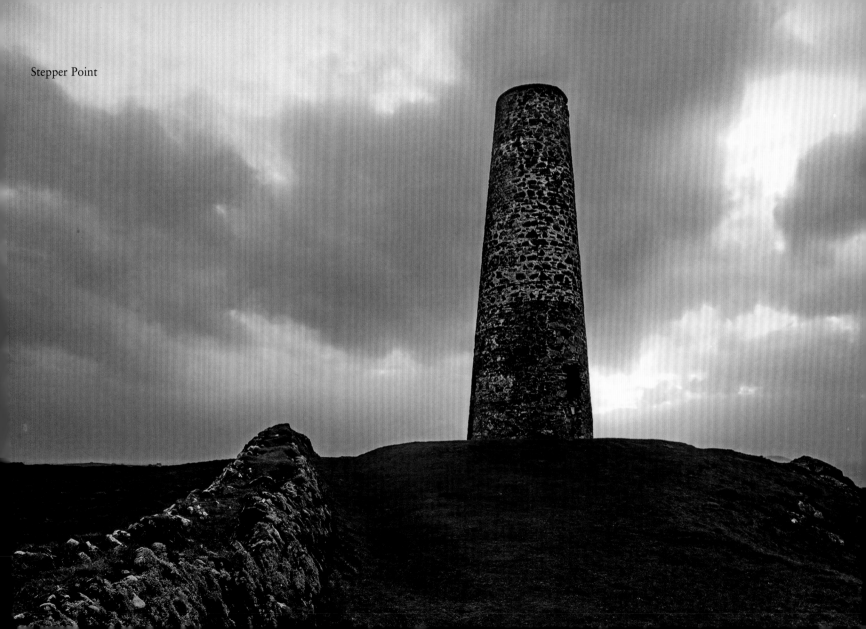

Stepper Point

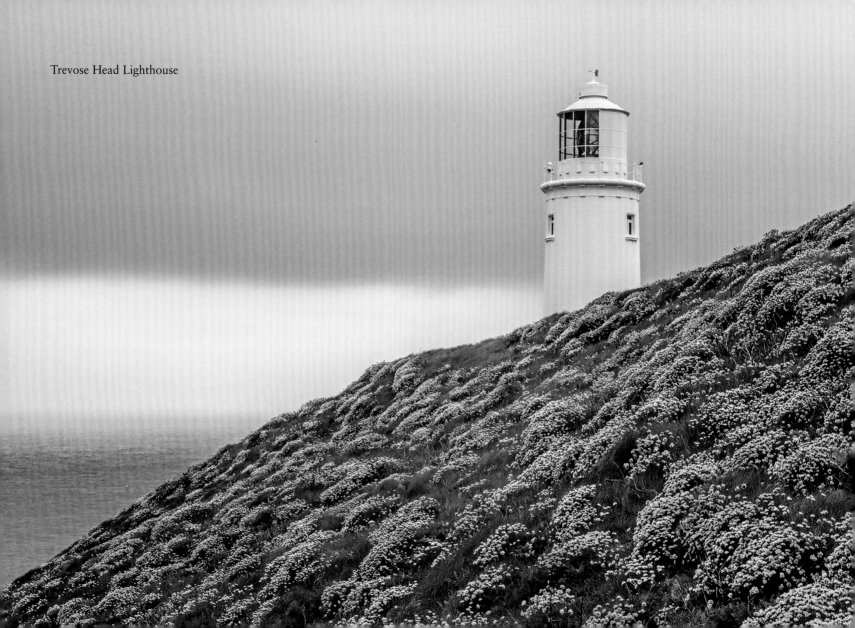

Trevose Head Lighthouse

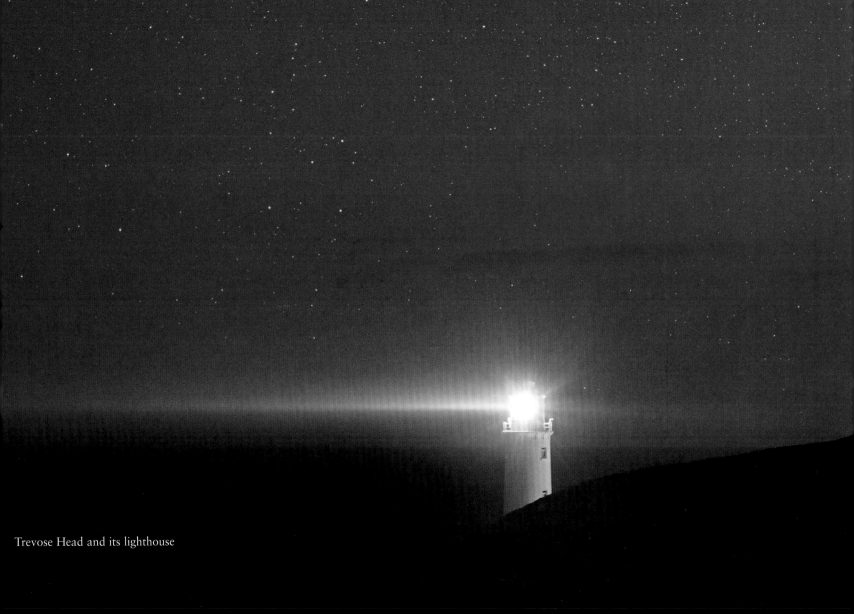

Trevose Head and its lighthouse

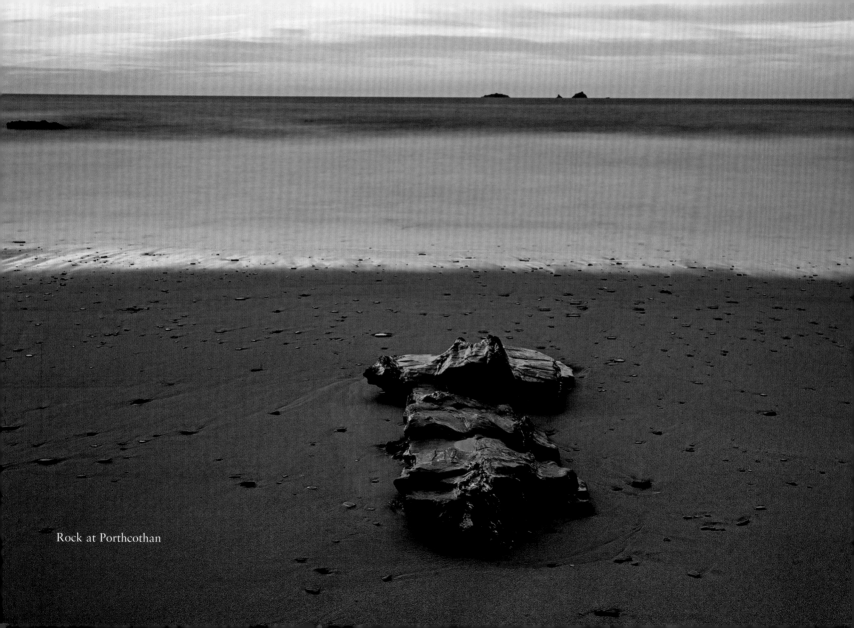

Rock at Porthcothan

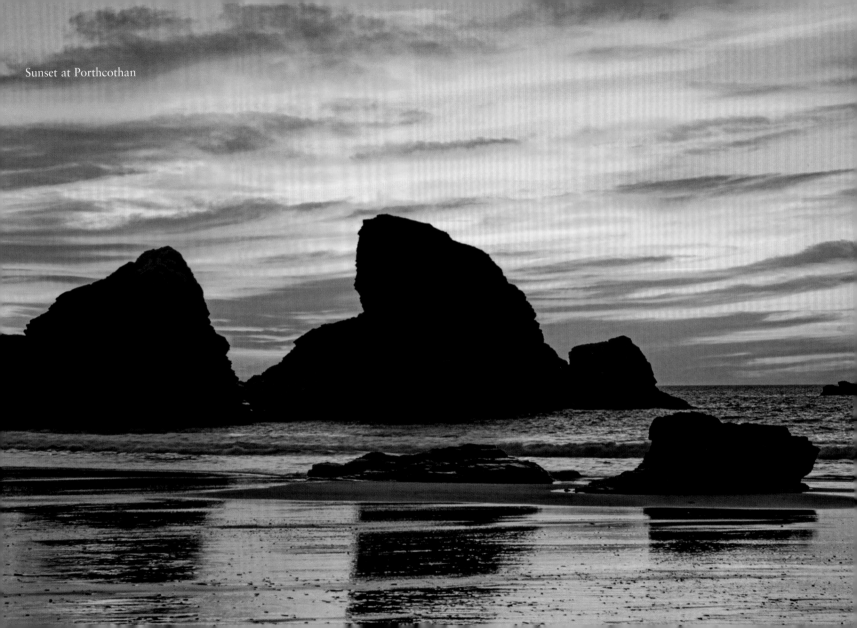

Sunset at Porthcothan

One of several beaches in Porthcothan

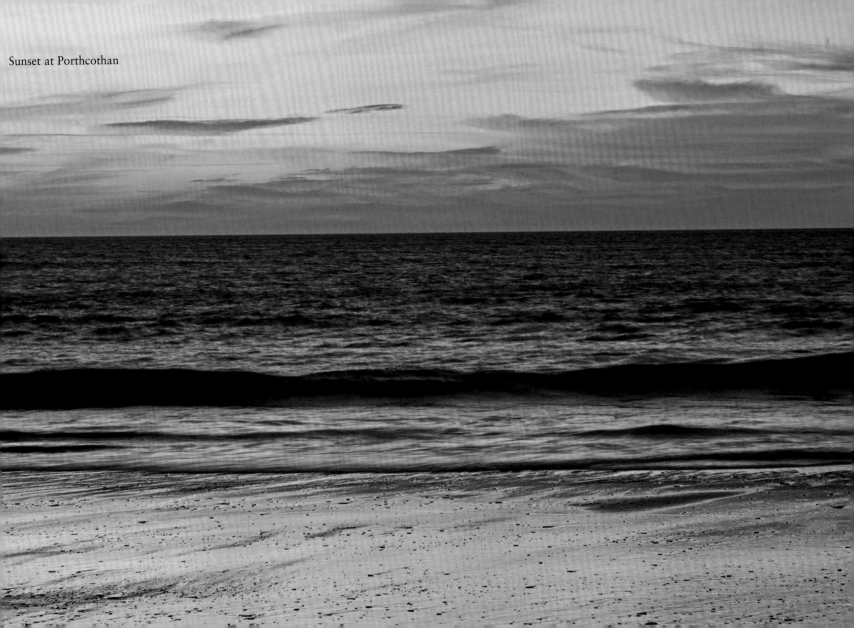

Sunset at Porthcothan

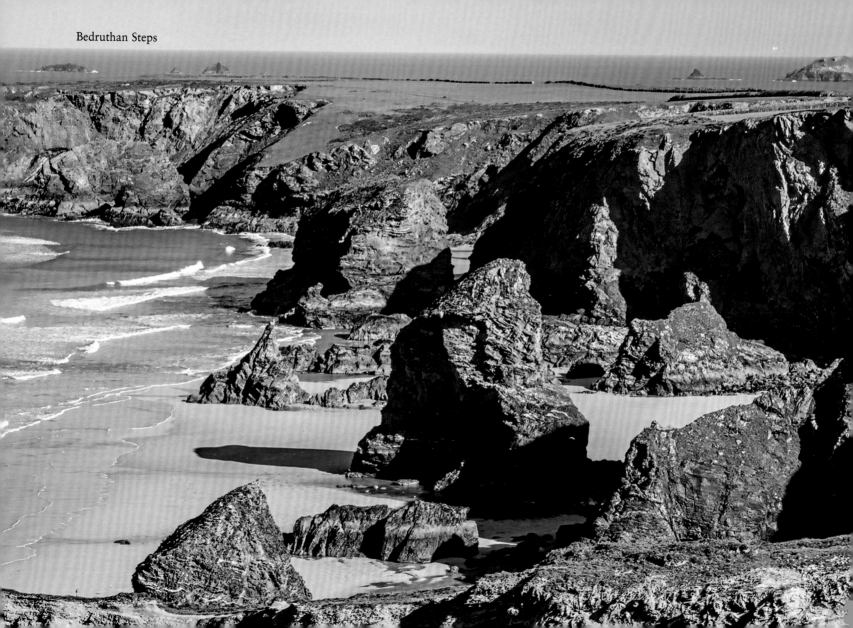

Bedruthan Steps

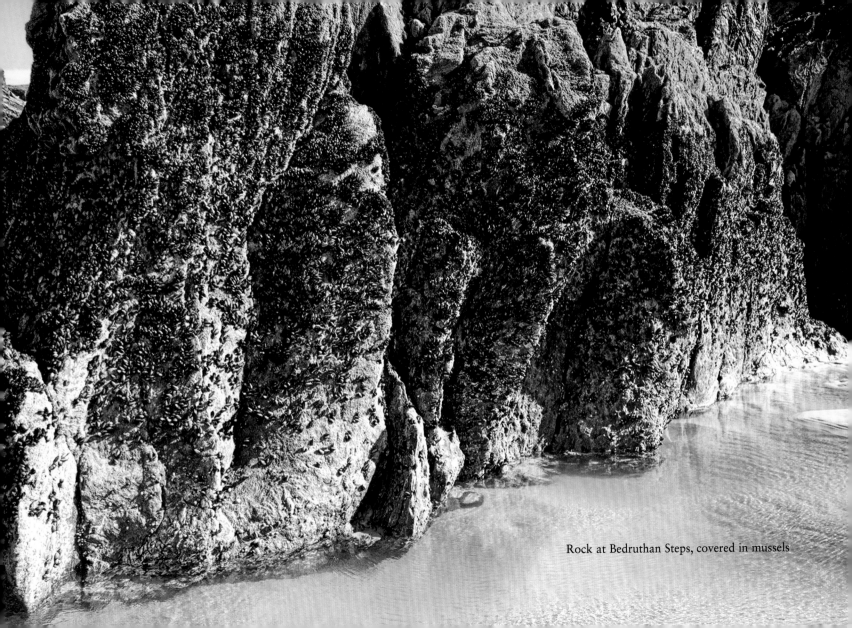

Rock at Bedruthan Steps, covered in mussels

Tracks on Bedruthan Steps Beach

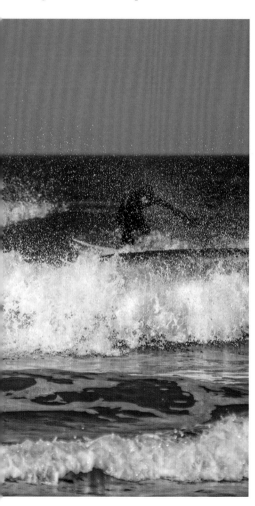
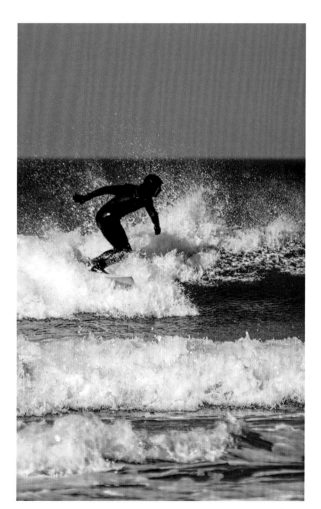
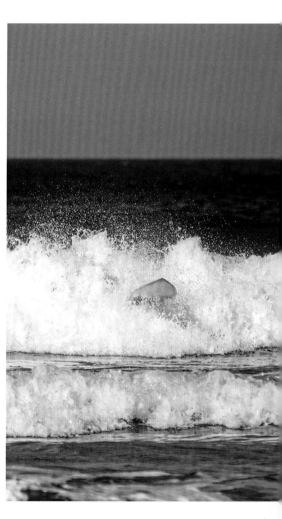

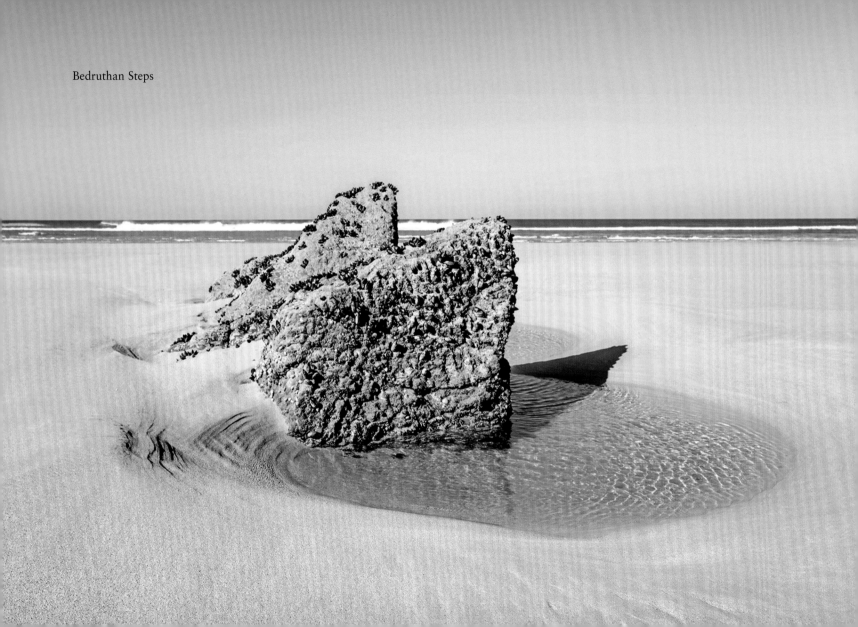

Bedruthan Steps

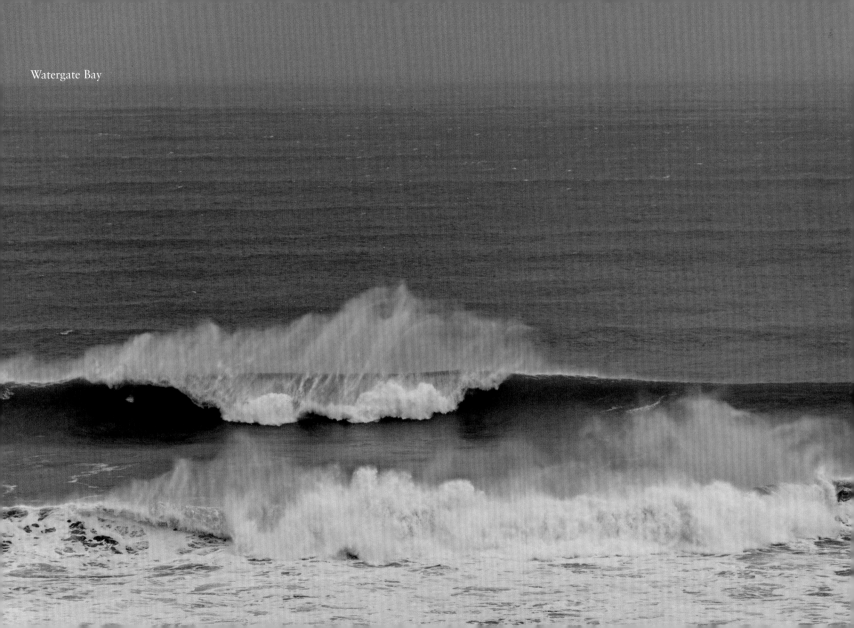

Watergate Bay

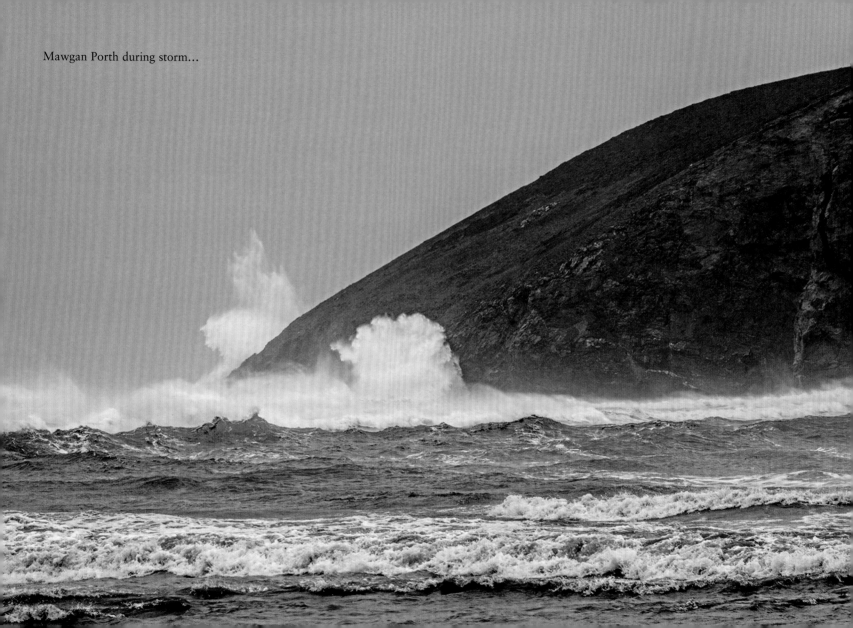

Mawgan Porth during storm…

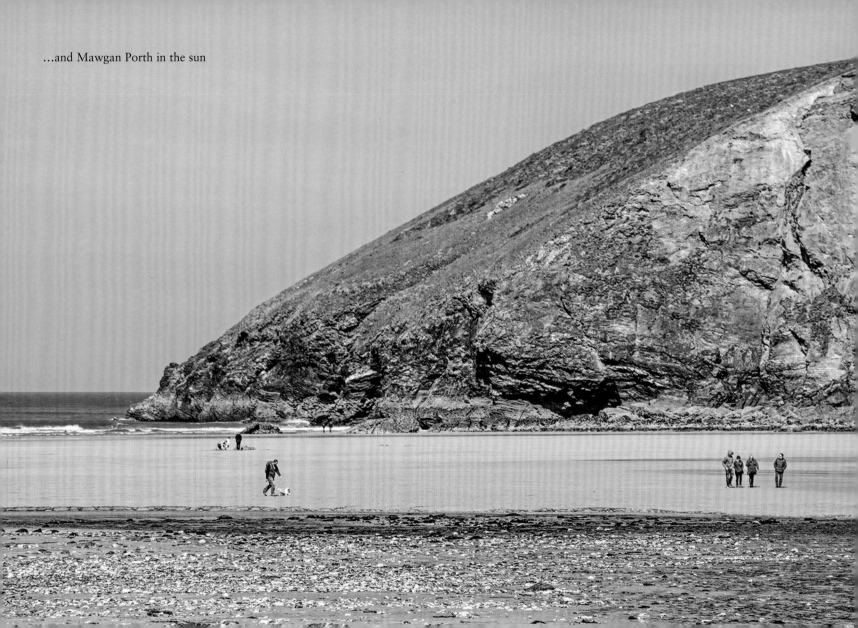

...and Mawgan Porth in the sun

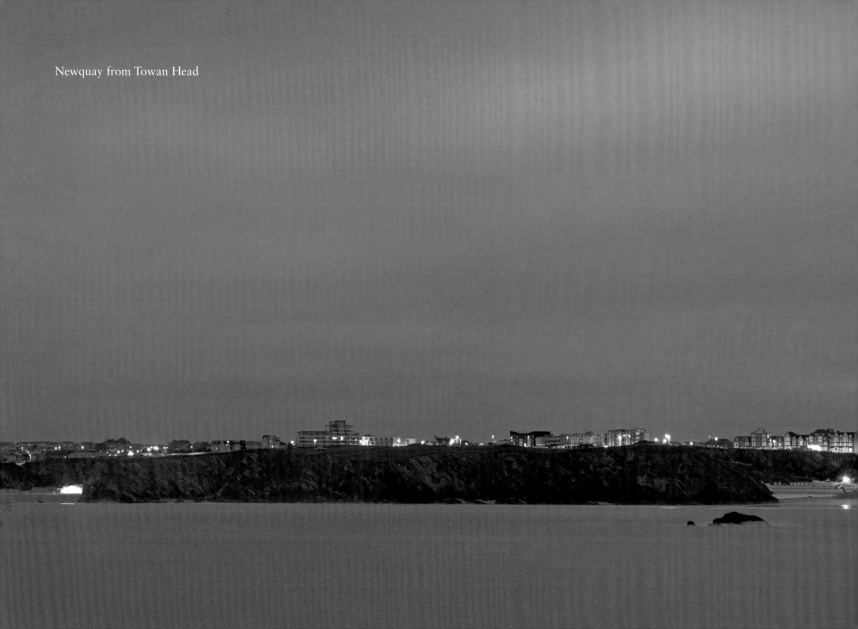

Newquay from Towan Head

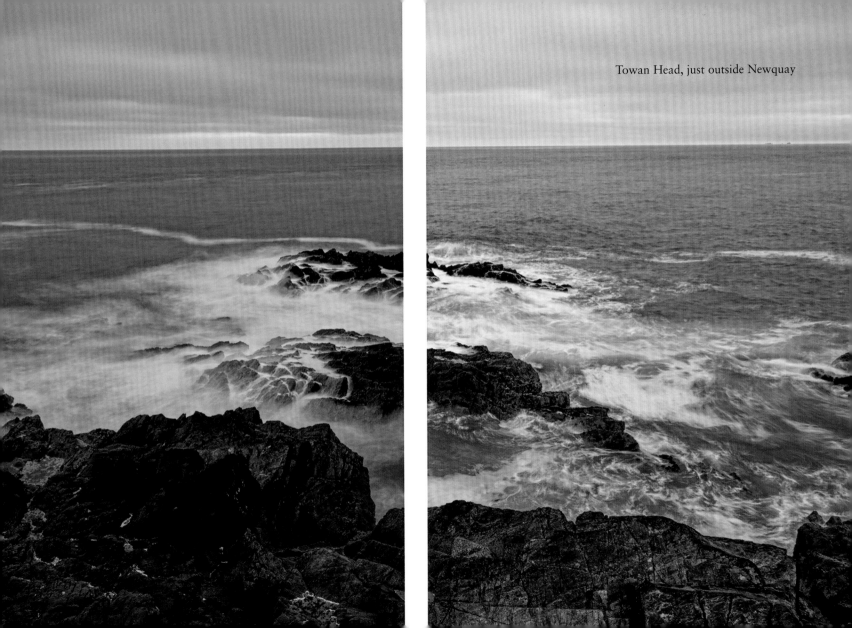

Towan Head, just outside Newquay

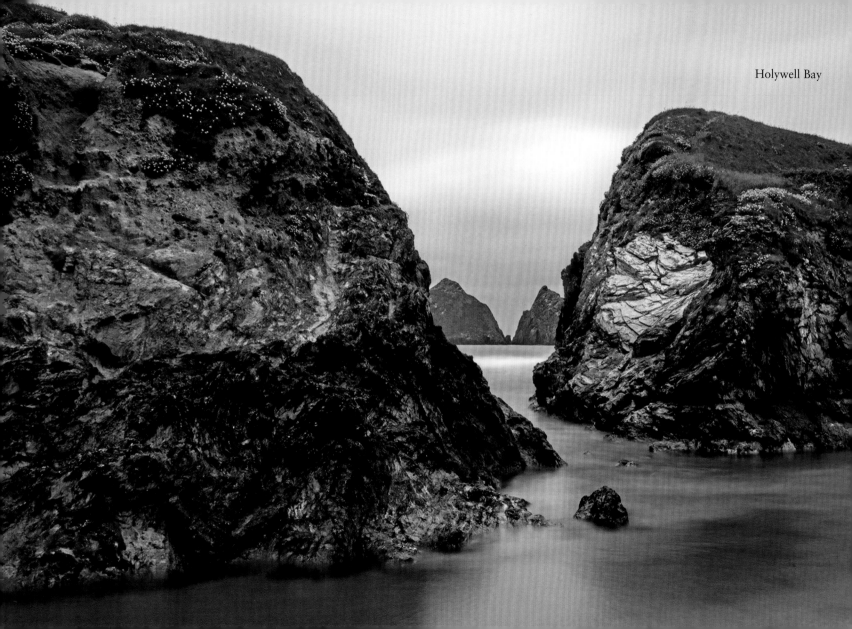

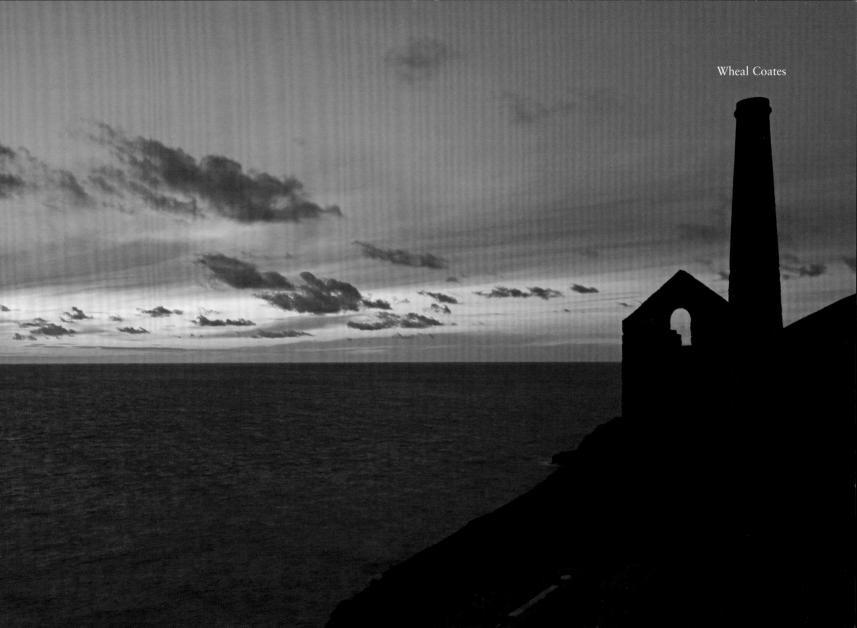

Wheal Coates

THE WESTERN COAST OF CORNWALL

Probably the most recognisable part of Cornwall to many people, its western coast offers a dramatic coastline and, as it points to the west, spectacular sunsets. Artists in and around the town of St Ives have been taking advantage of these sunsets and the supposedly different light for almost 150 years, and continue to do so.

This part of Cornwall is quite concentrated and thus allows for visits to a variety of places at a leisurely pace. Apart from its spectacular coastline, it also offers a distinct wildlife, shaped by the strong winds coming in from the Atlantic Ocean. Even though many popular Cornish sites can be found in this area, there is still much room for exploring places that may not be on postcards but are still exceedingly charming and quaint.

The western coast is a paradise for trekkers, artists, and anyone who simply wants to relax. Weather can be harsh and the winds exceptional, yet this adds to the overall atmosphere found here. Being at the end of Cornwall also adds a sense of remoteness when looking over the sea, knowing that the next stop is North America. This realisation brings yet another sentiment that can be so particular of Cornwall.

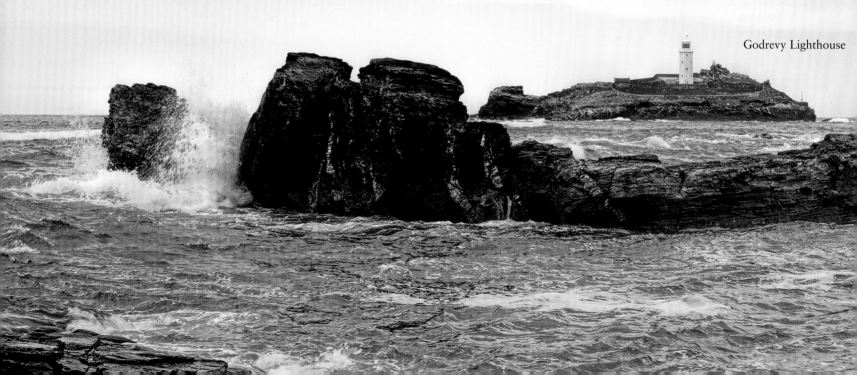

Godrevy Lighthouse

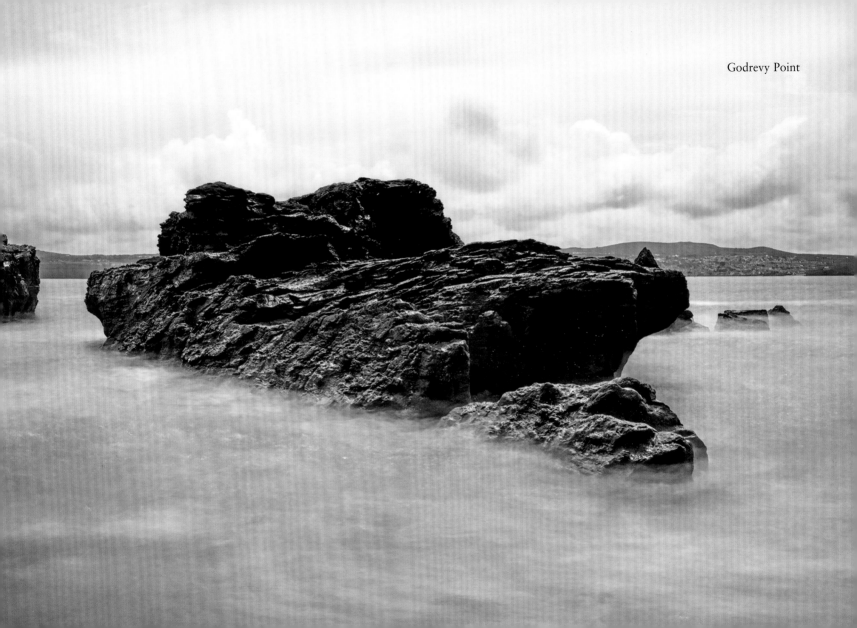

Godrevy Point

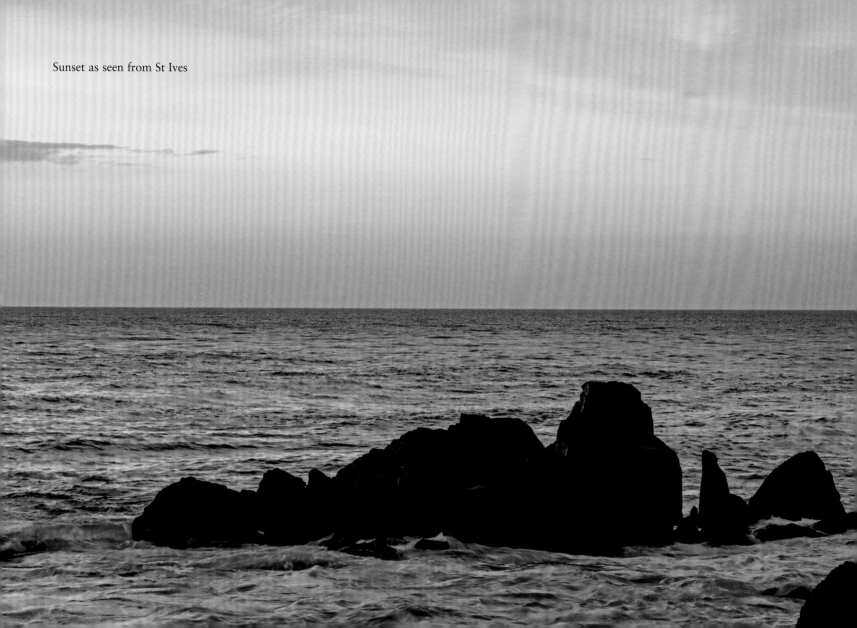

Sunset as seen from St Ives

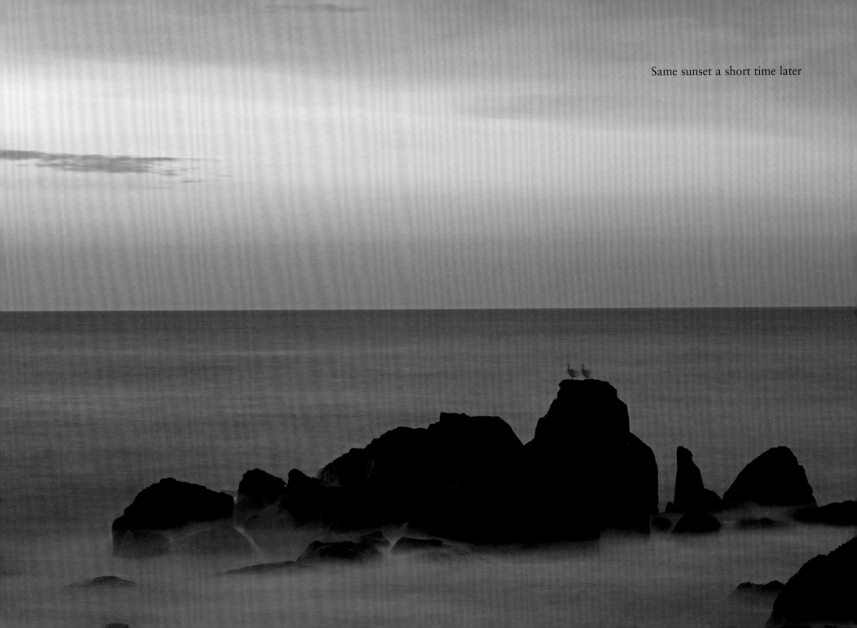

Same sunset a short time later

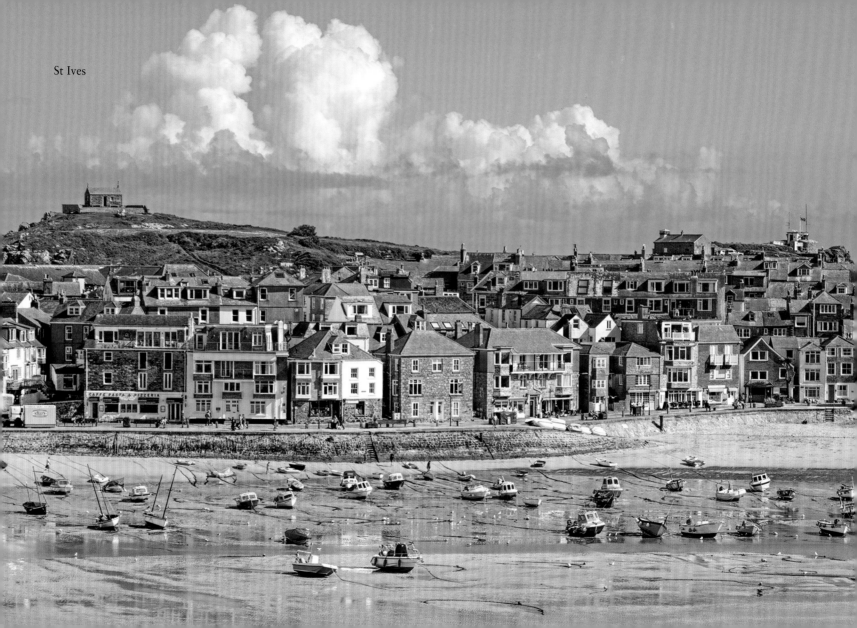

St Ives

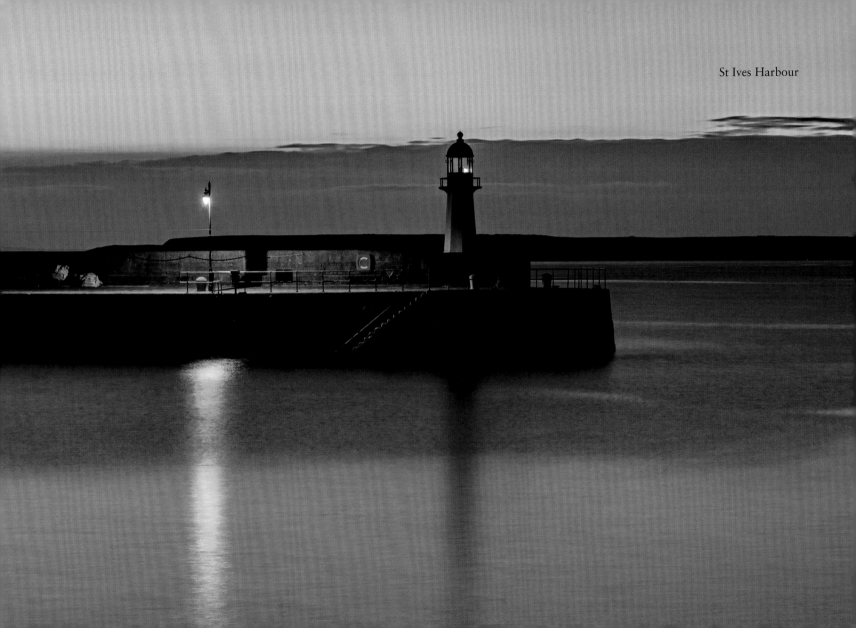

St Ives Harbour

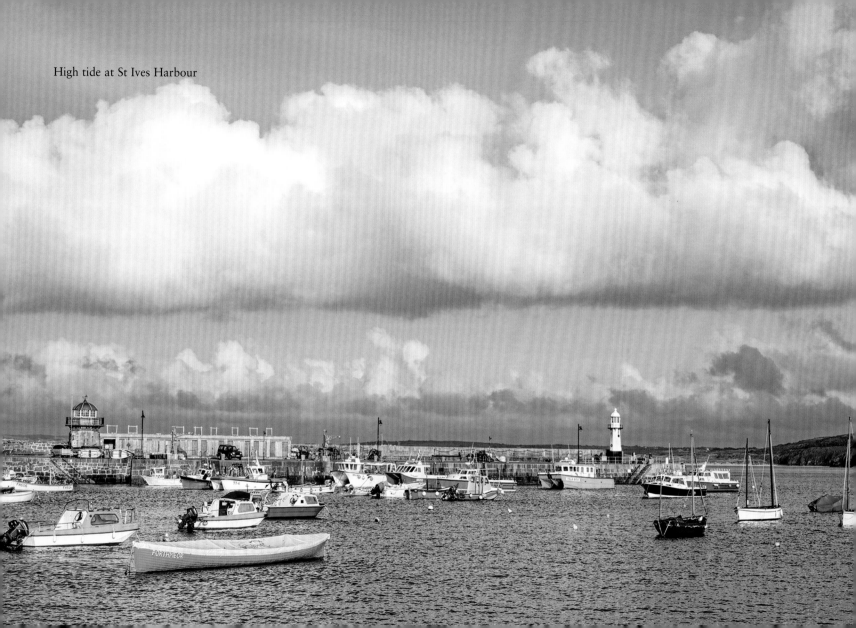

High tide at St Ives Harbour

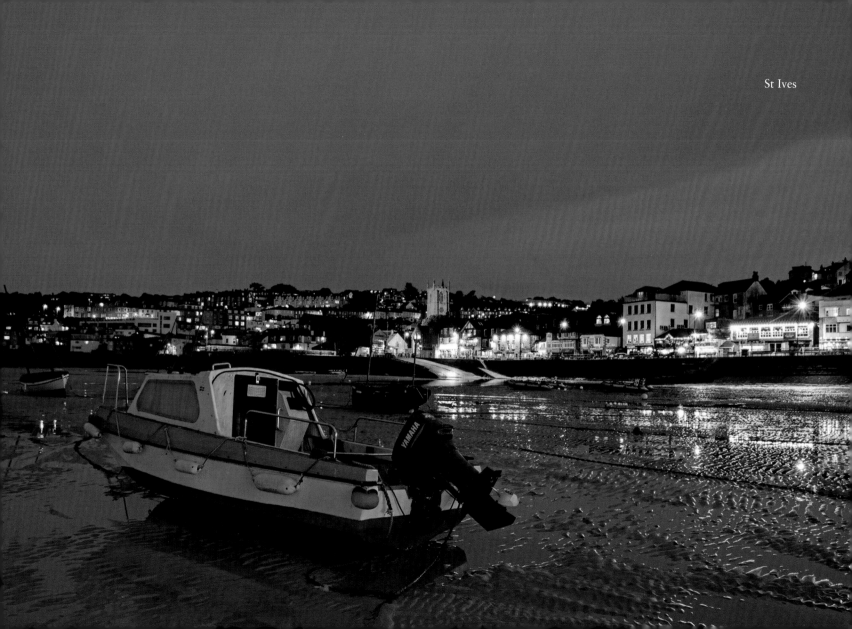
St Ives

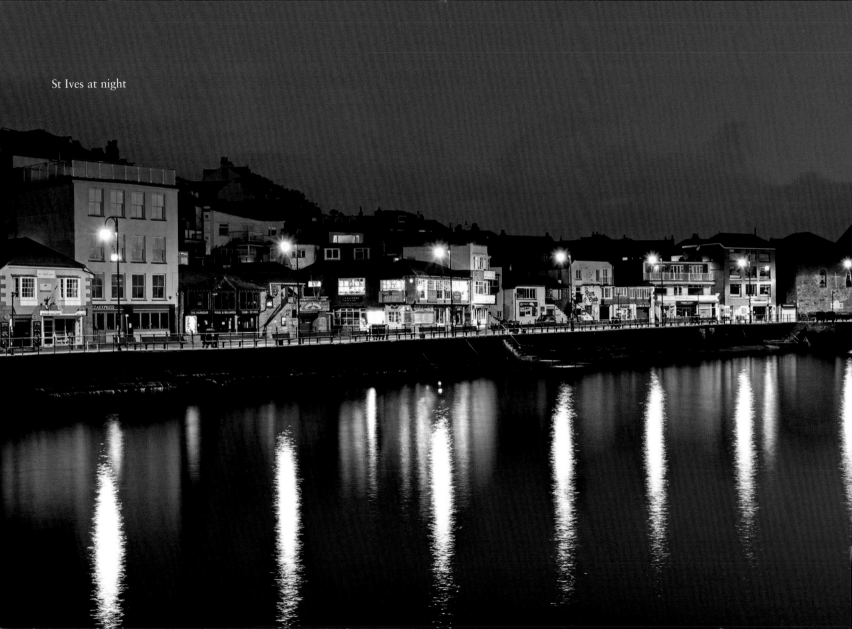

St Ives at night

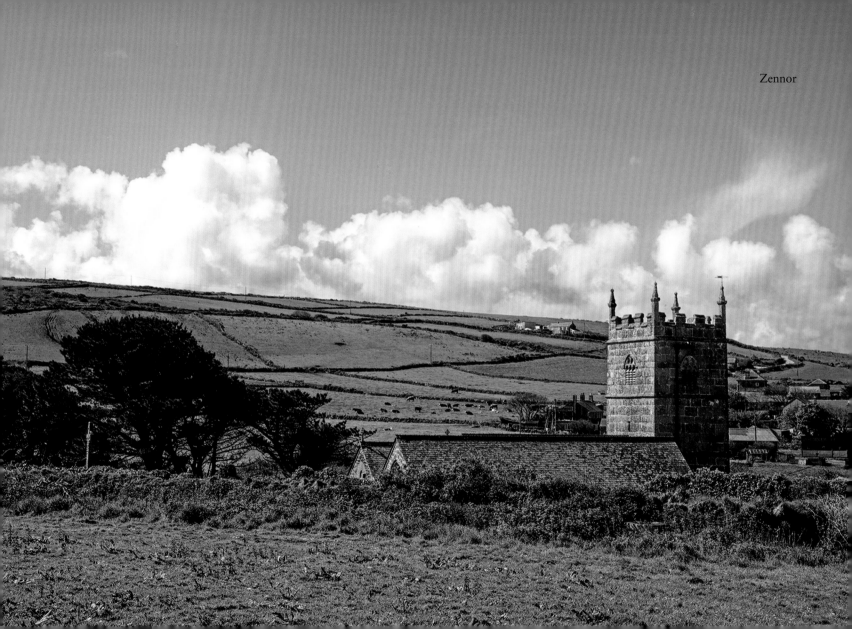

Zennor

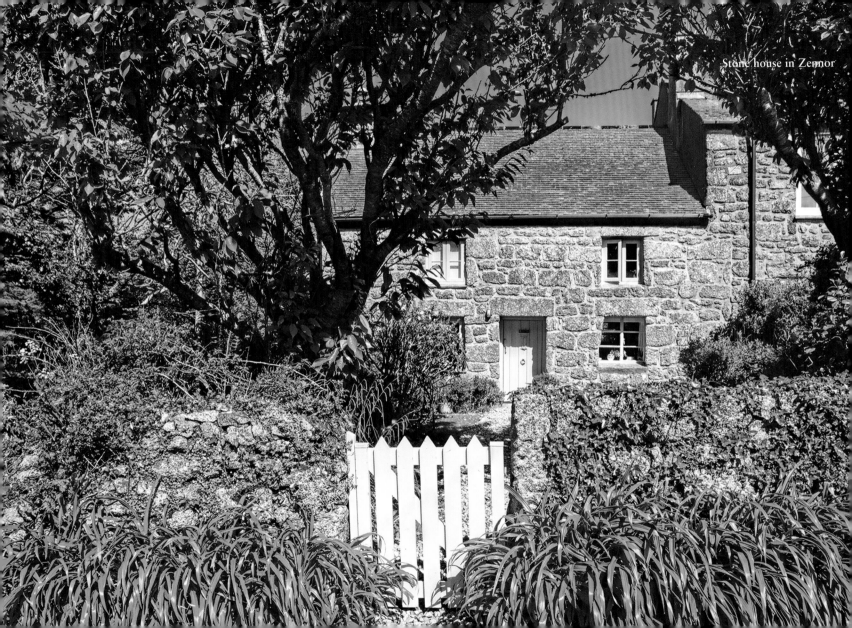

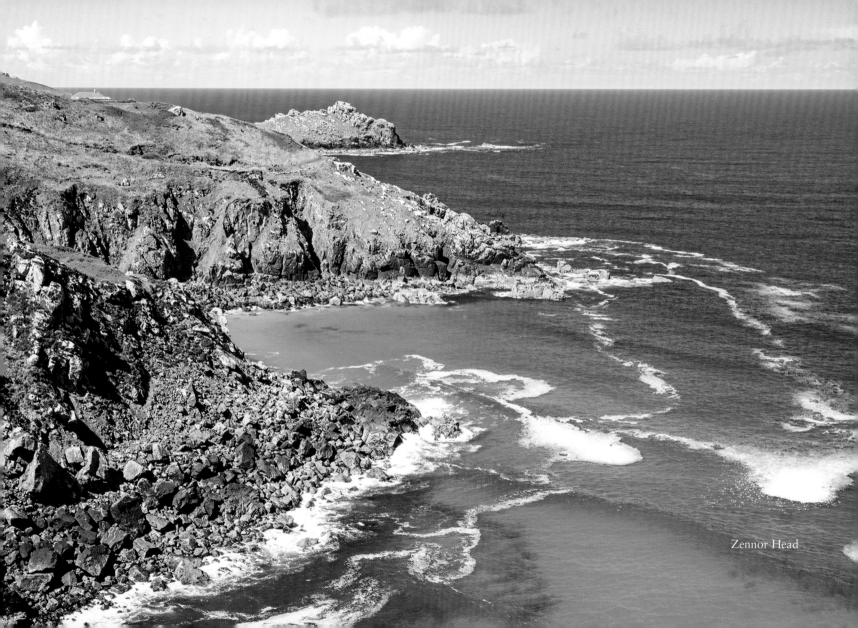

Zennor Head

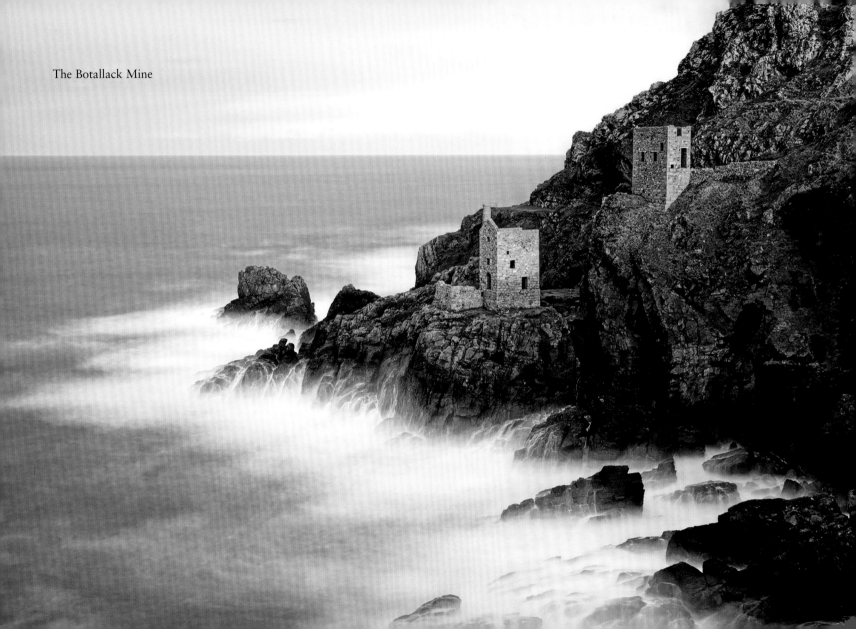

The Botallack Mine

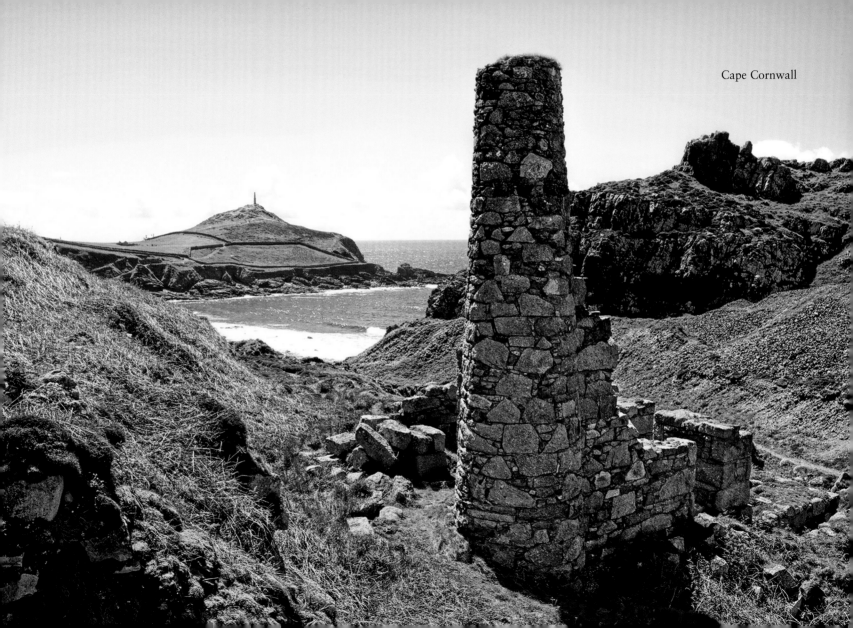

Cape Cornwall

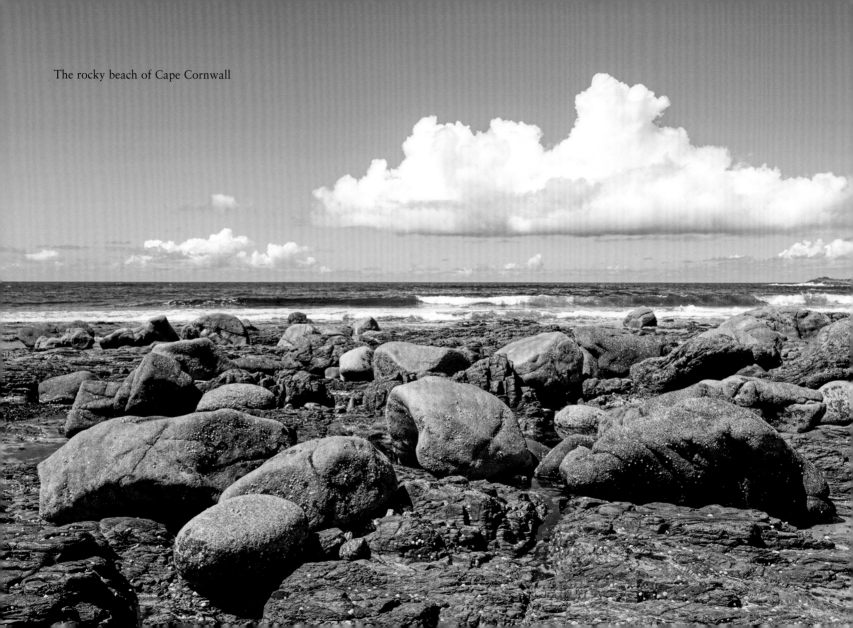
The rocky beach of Cape Cornwall

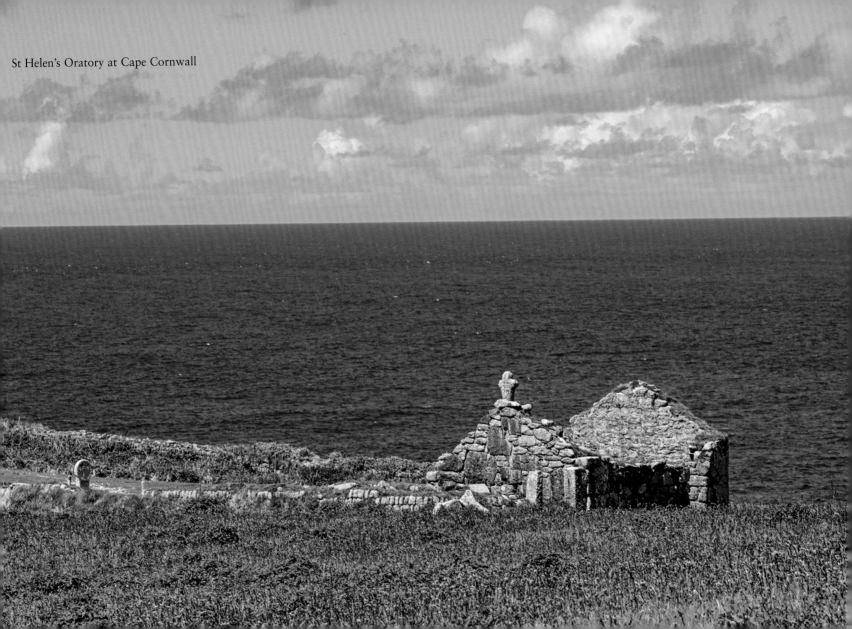

St Helen's Oratory at Cape Cornwall

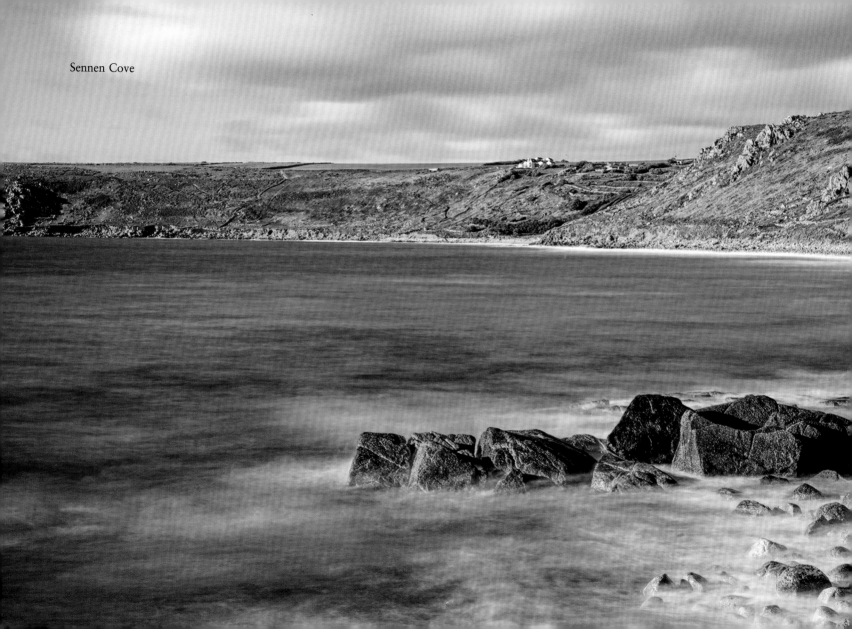

Sennen Cove

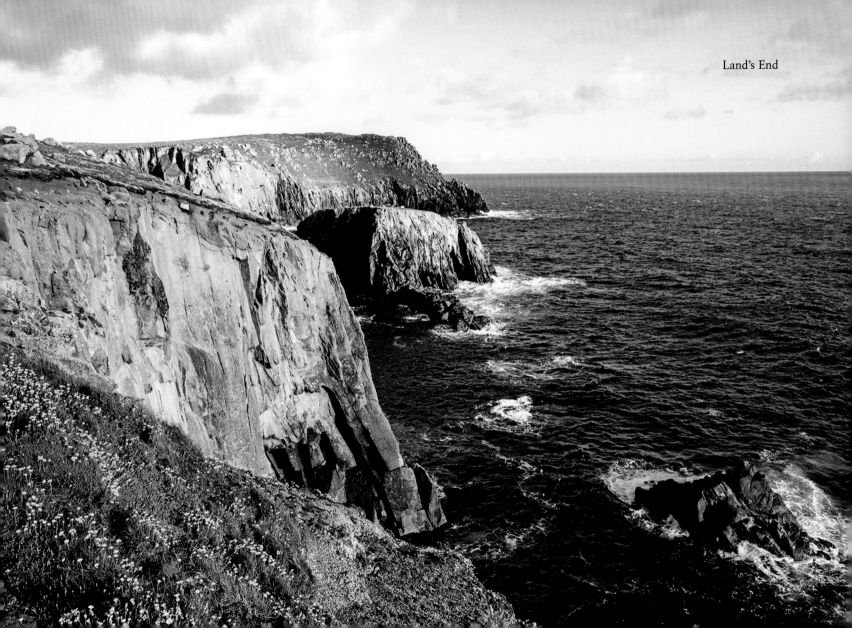

Land's End

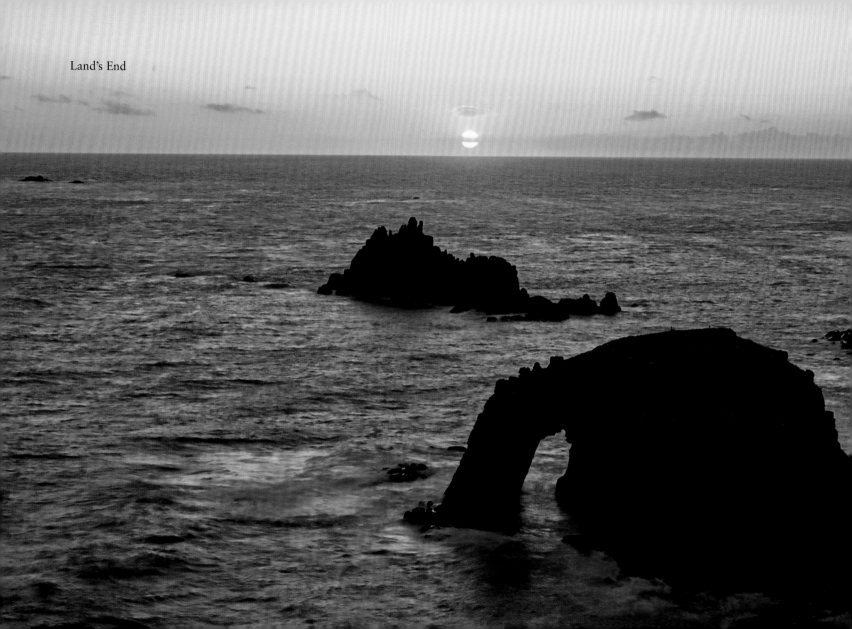

Land's End

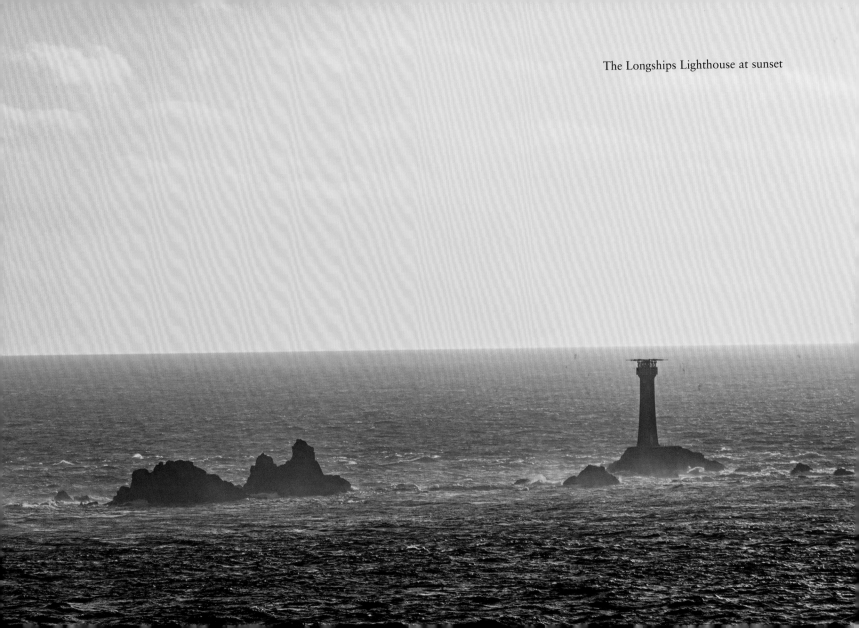

The Longships Lighthouse at sunset

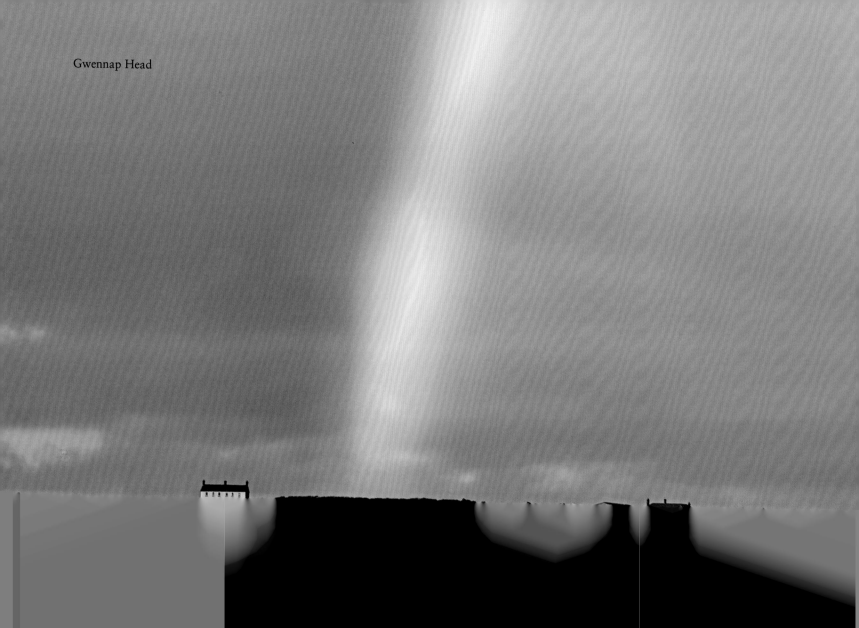

Gwennap Head

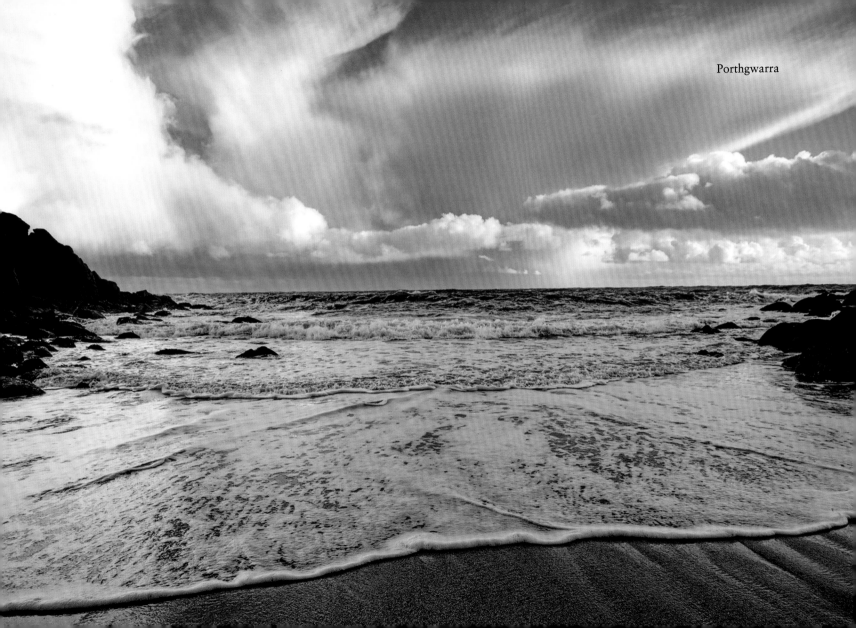

Porthgwarra

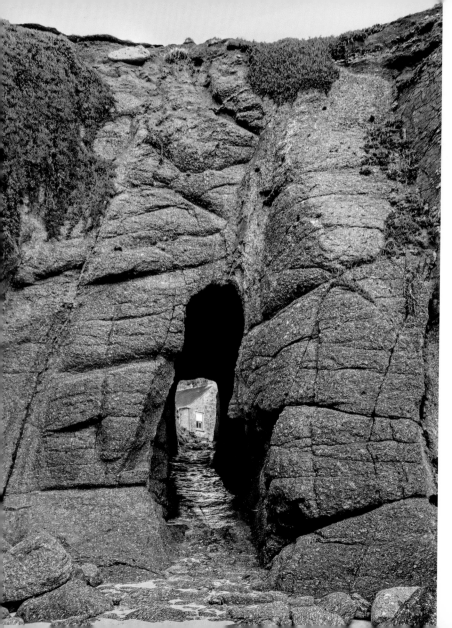

A tunnel from Porthgwarra village down to the sea

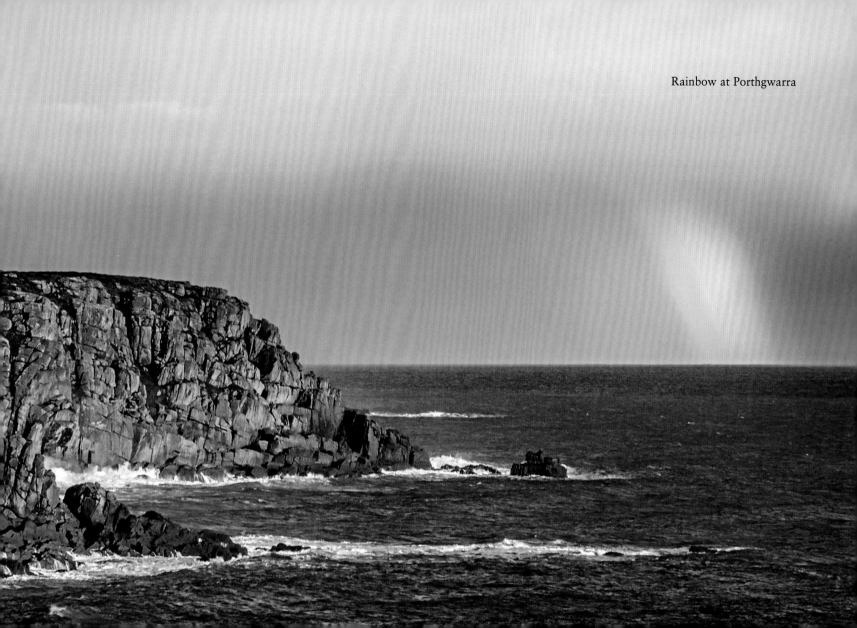

Rainbow at Porthgwarra

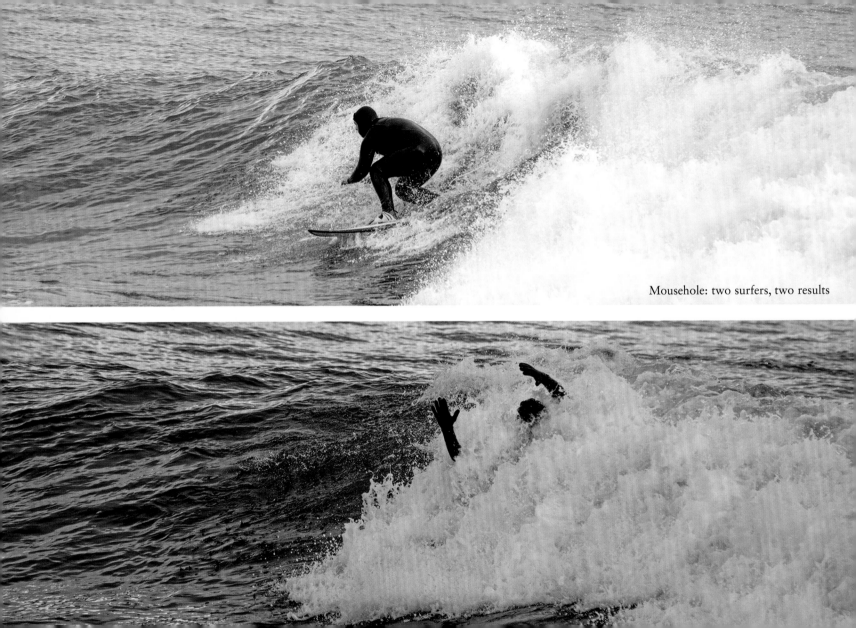

Mousehole: two surfers, two results

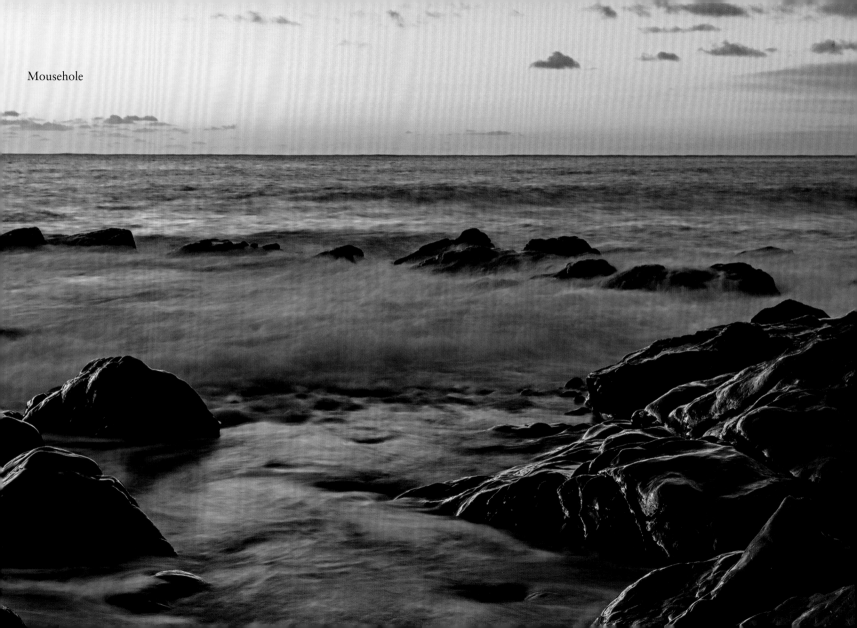

Mousehole

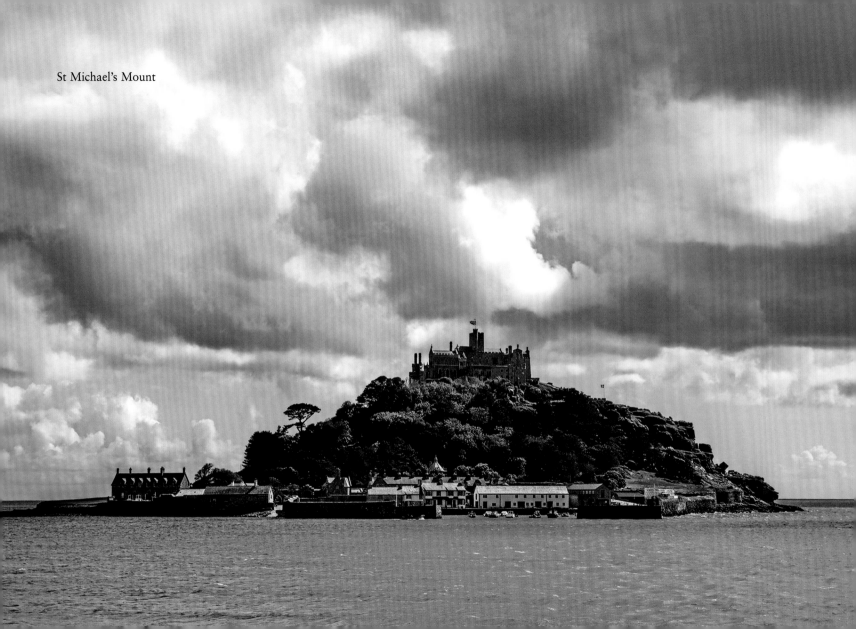

St Michael's Mount

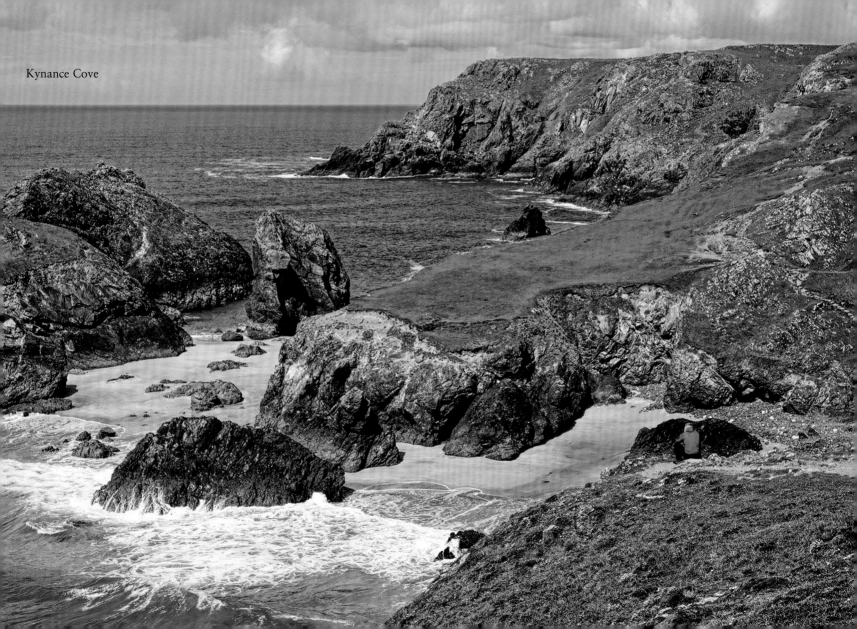

Kynance Cove

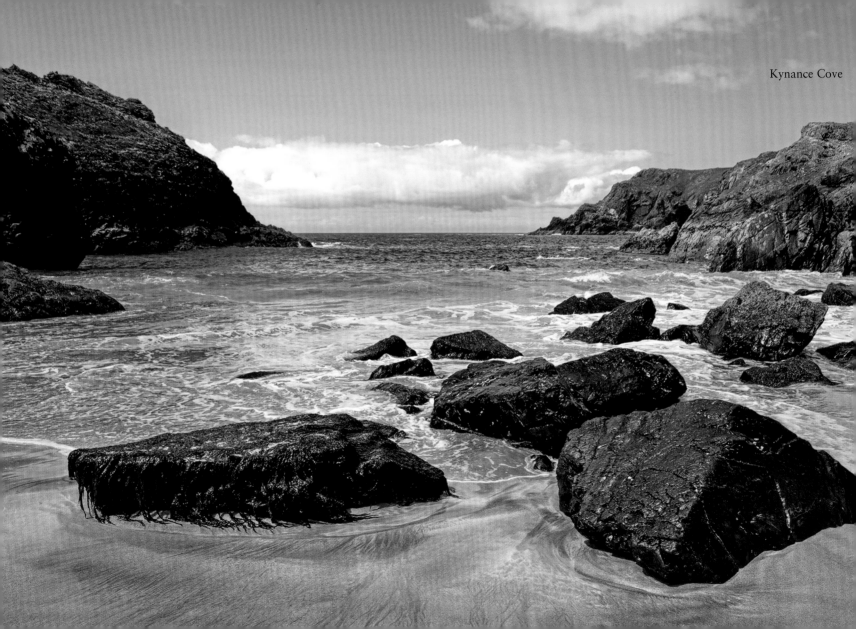

Kynance Cove

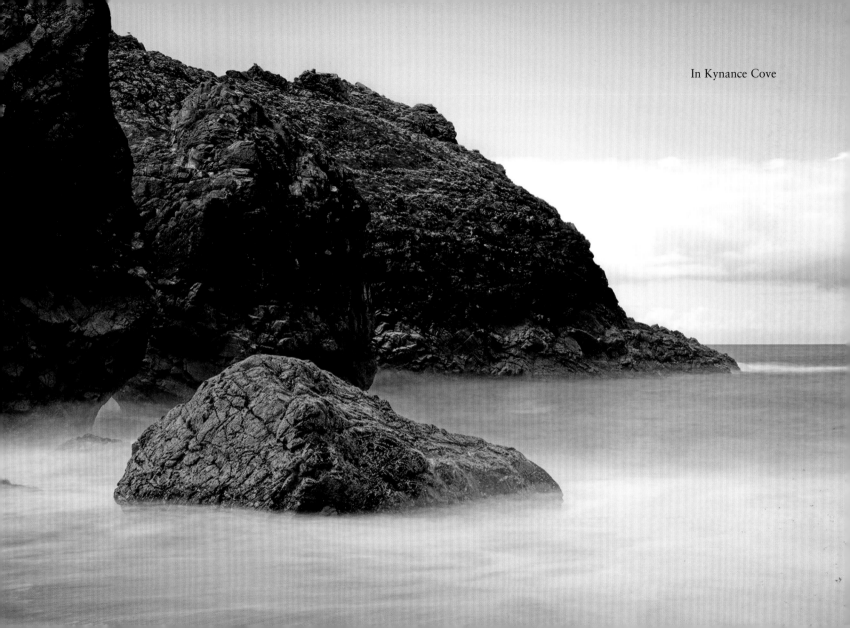

In Kynance Cove

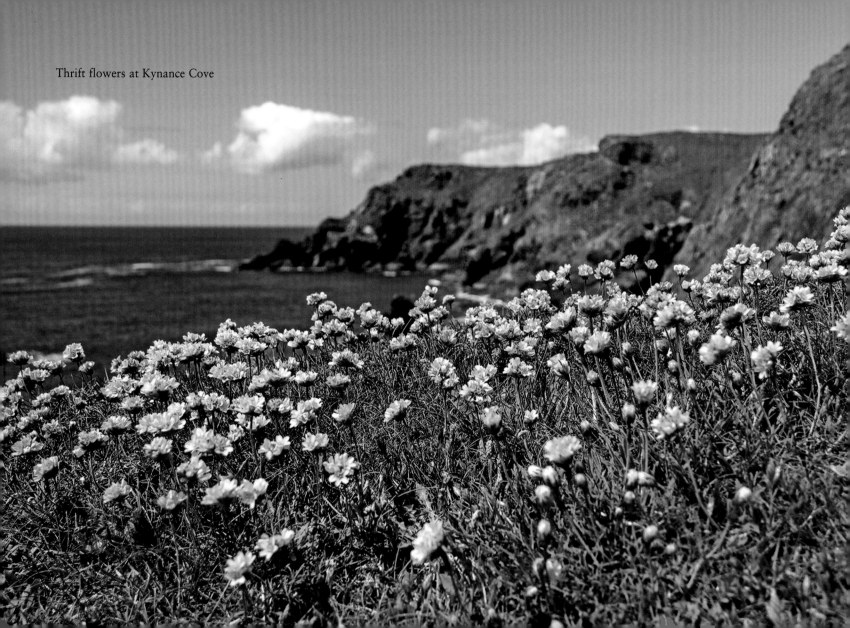

Thrift flowers at Kynance Cove

THE SOUTHERN COAST OF CORNWALL

The southern Cornish coast roughly extends from the River Tamar with Plymouth on the other side (Plymouth not being in Cornwall but in Devon) down to the area around Falmouth. This stretch of coast gives an impression of being slightly less rugged than the north and west of Cornwall, due to its greener vegetation and the numerous picturesque fishing villages. These villages often have very restricted car access in the centre, thus making them a joy and relaxing to explore by foot.

Given that the southern coast is somewhat less exposed to the elements than the north and west, it also lends itself to a wide variety of water-related activities for all ages and capacities. Even so, the southern coast retains much of what makes Cornwall dramatic and majestic, presenting impressive rocks and cliffs in between beaches and villages.

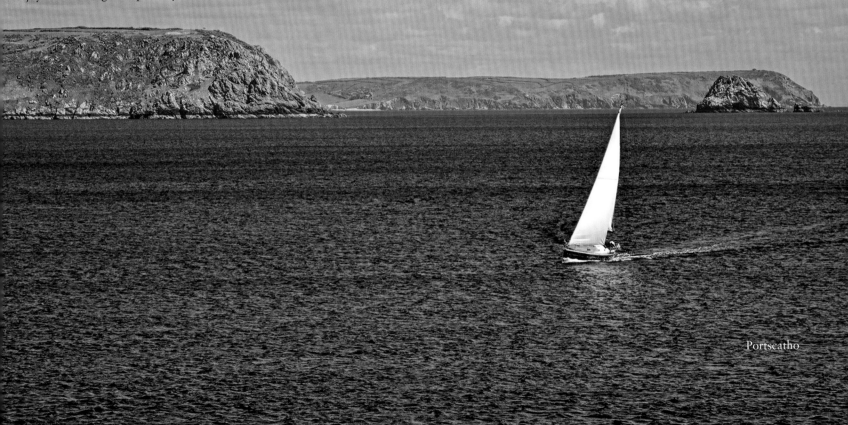

Portscatho

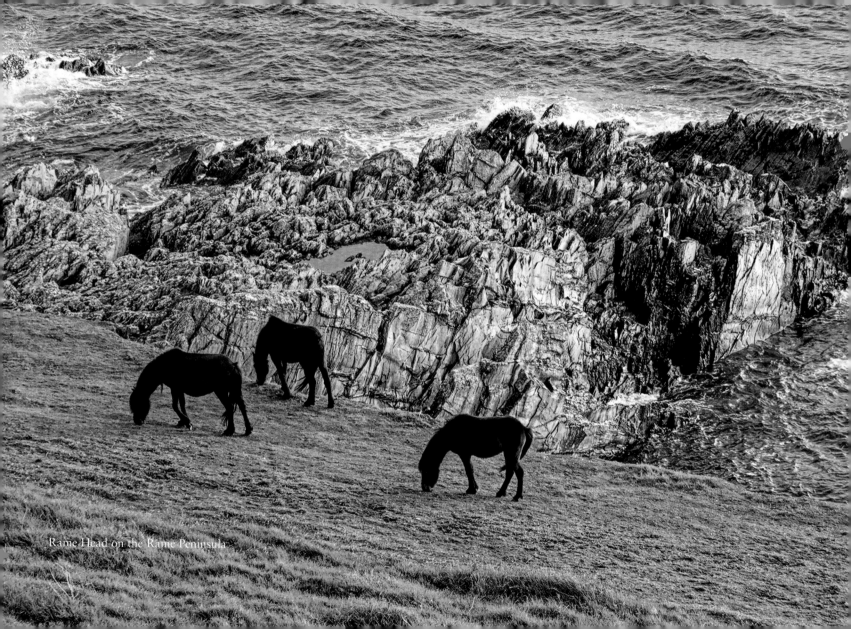

Rame Head on the Rame Peninsula

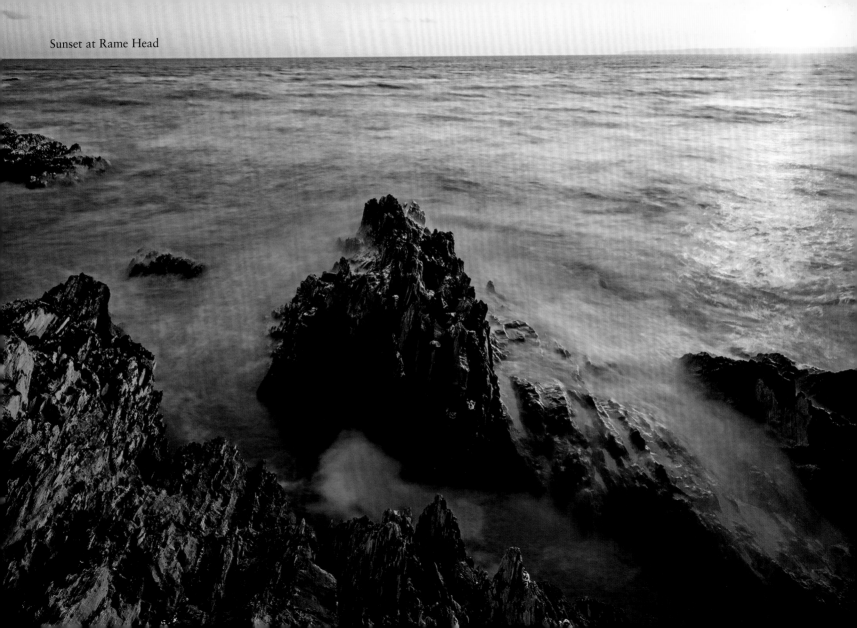

Sunset at Rame Head

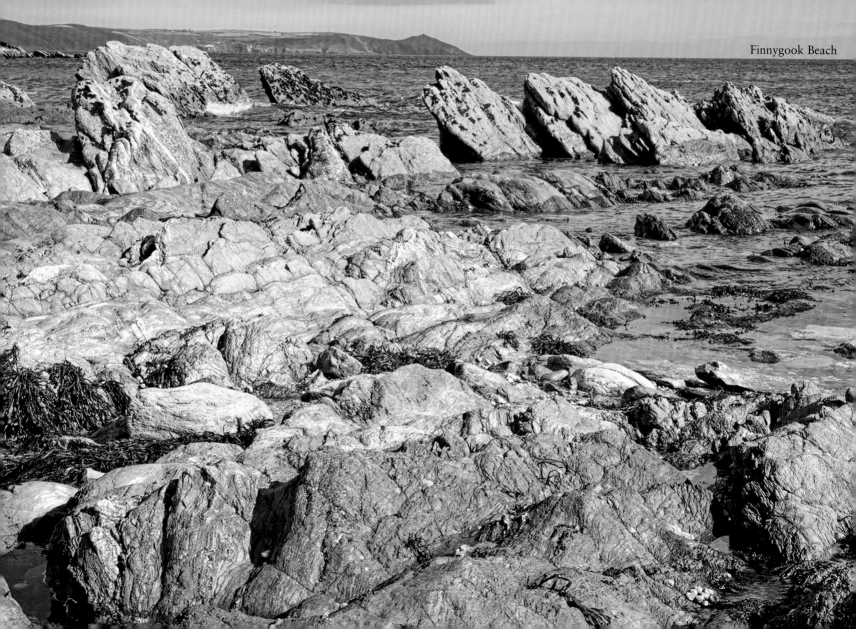

Finnygook Beach

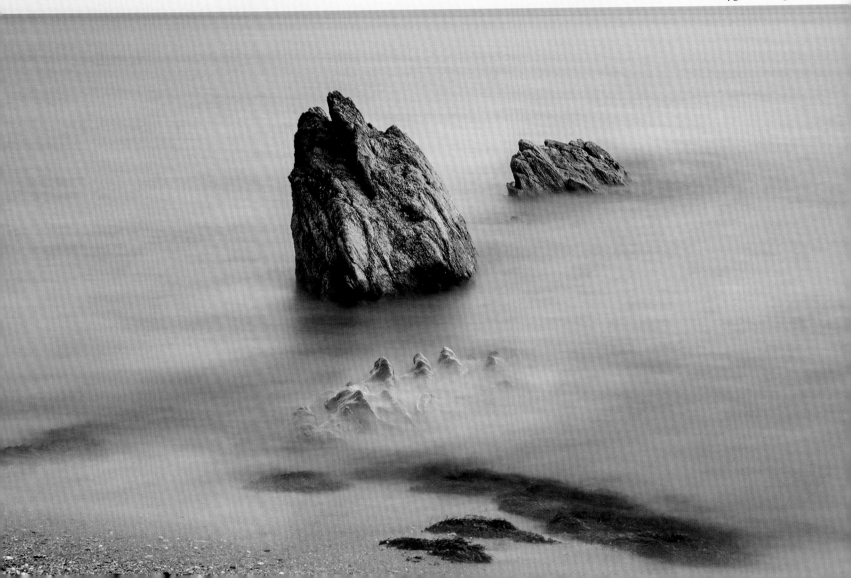

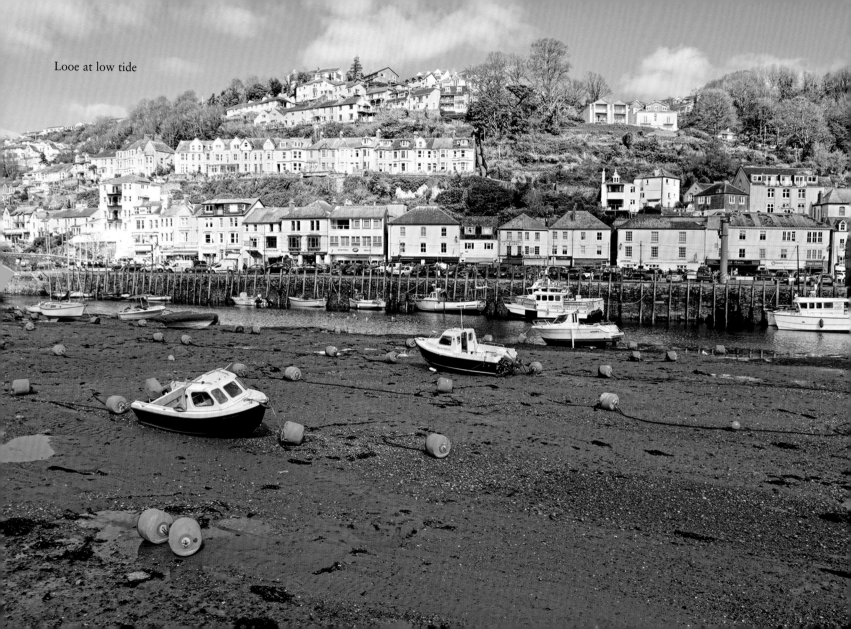

Looe at low tide

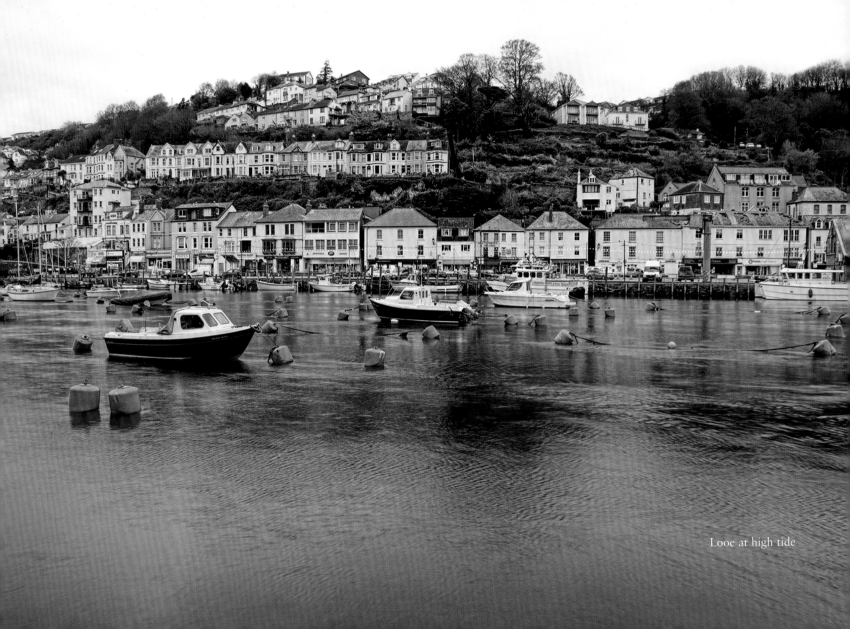

Looe at high tide

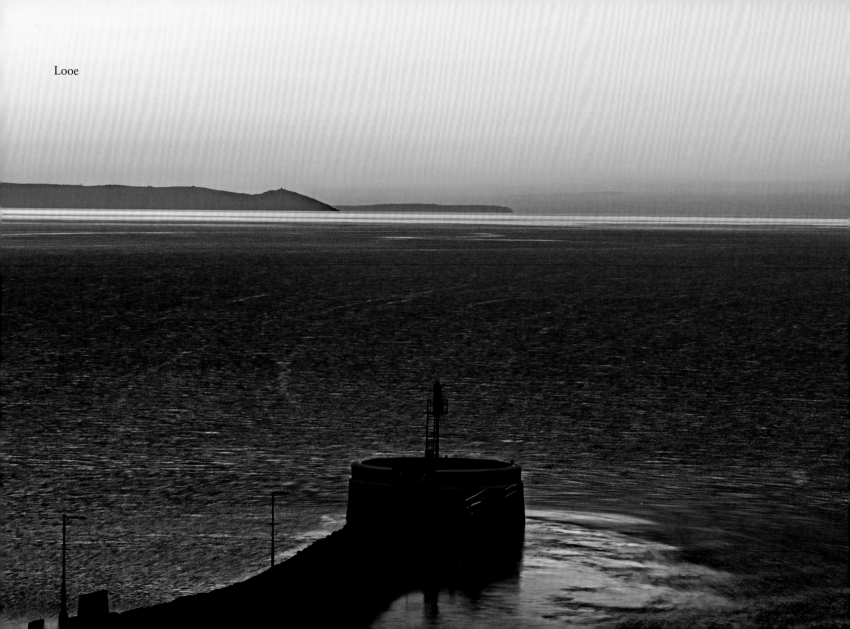

Looe

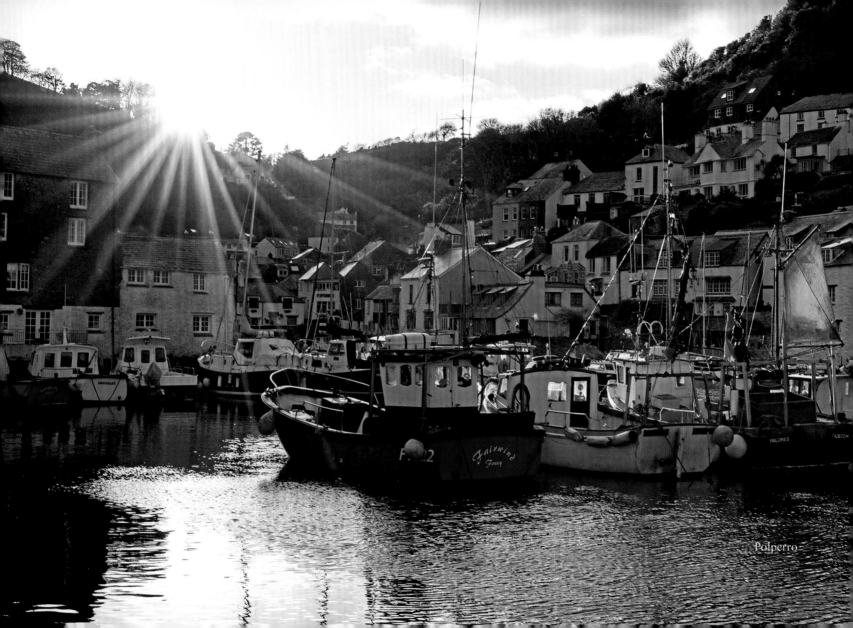

Polperro

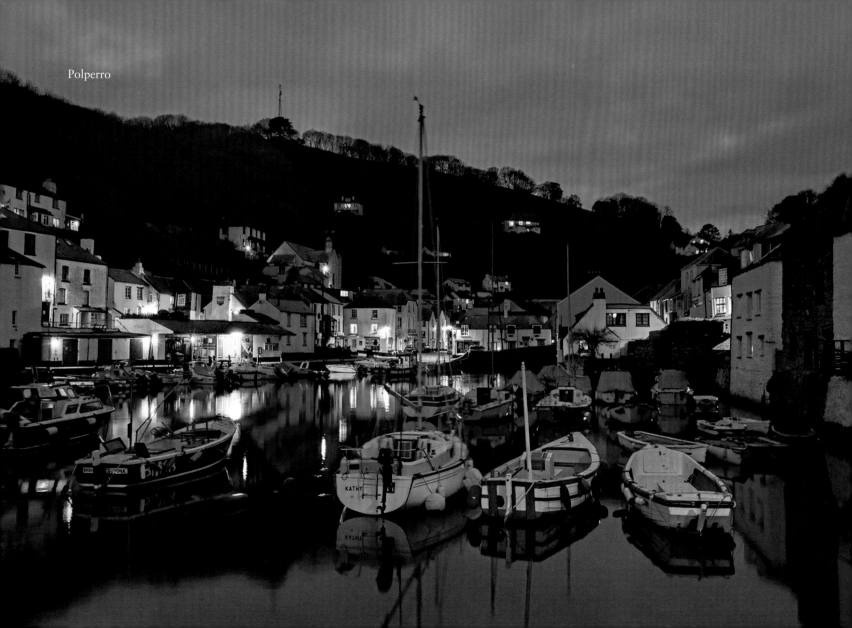

Polperro

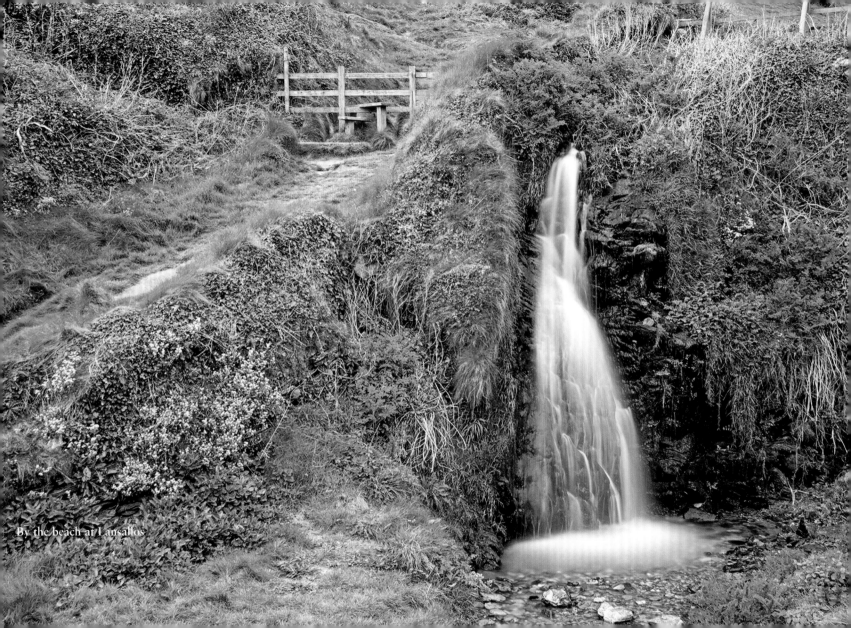

By the beach at Lansallos

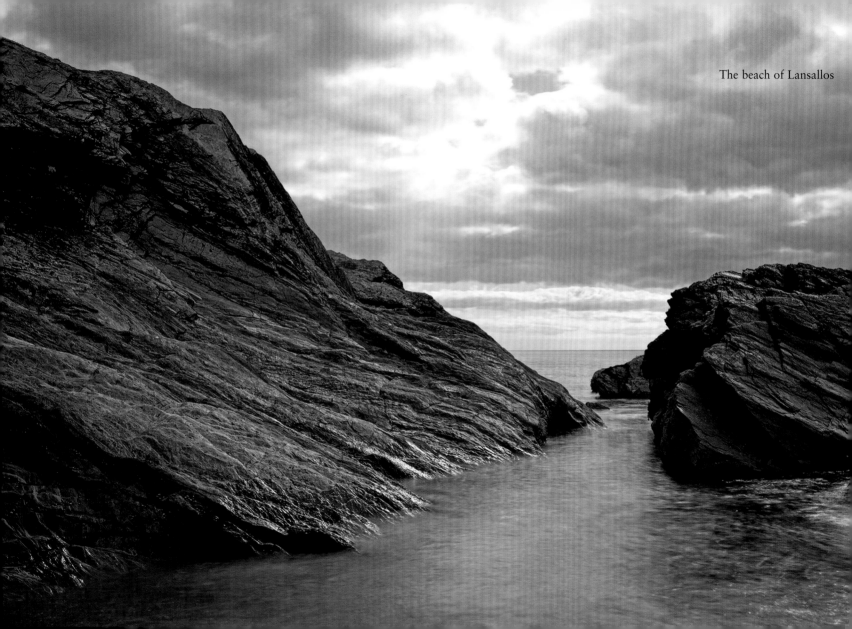

The beach of Lansallos

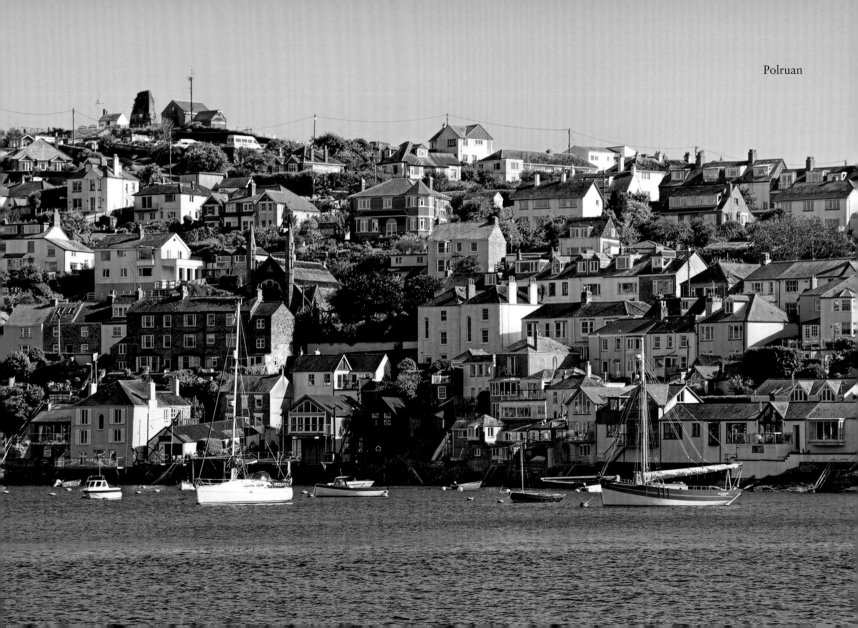

Polruan

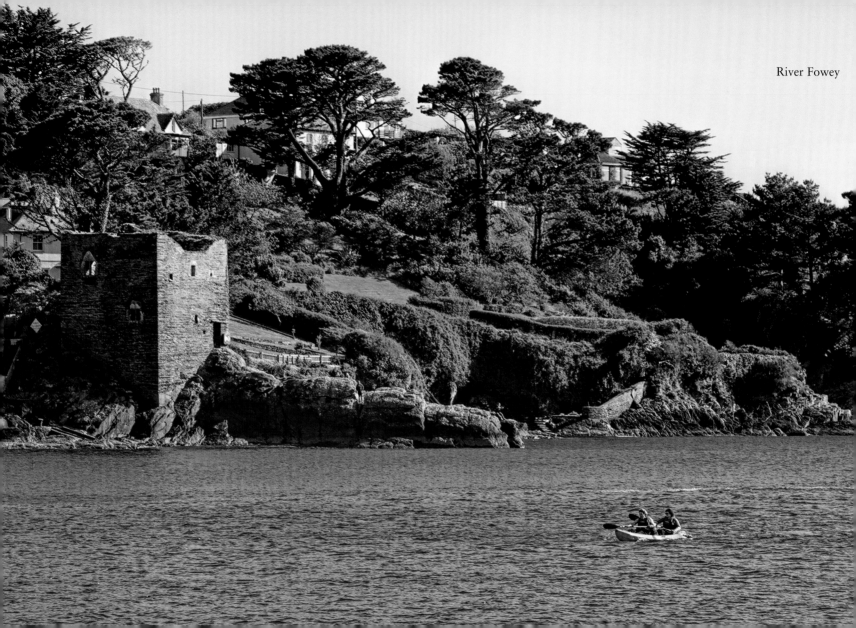

River Fowey

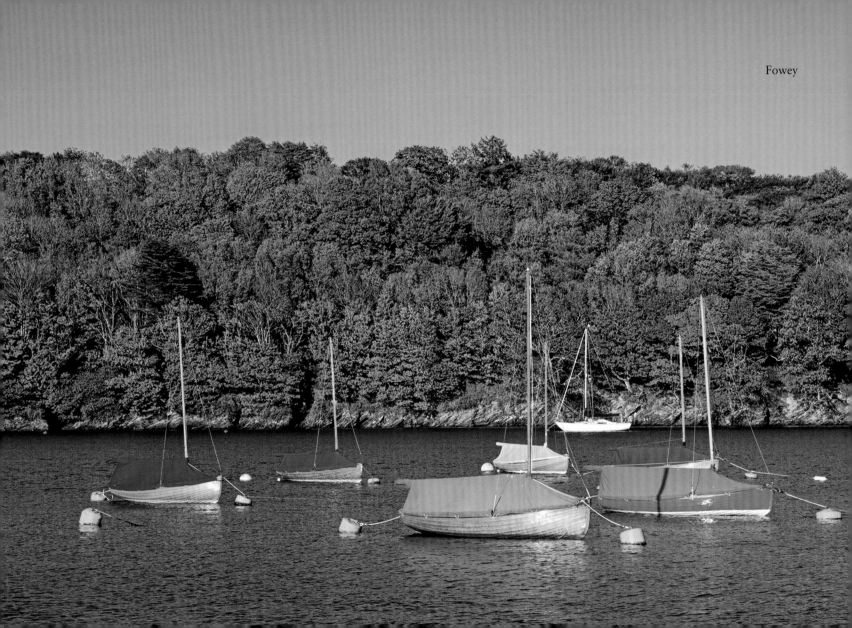

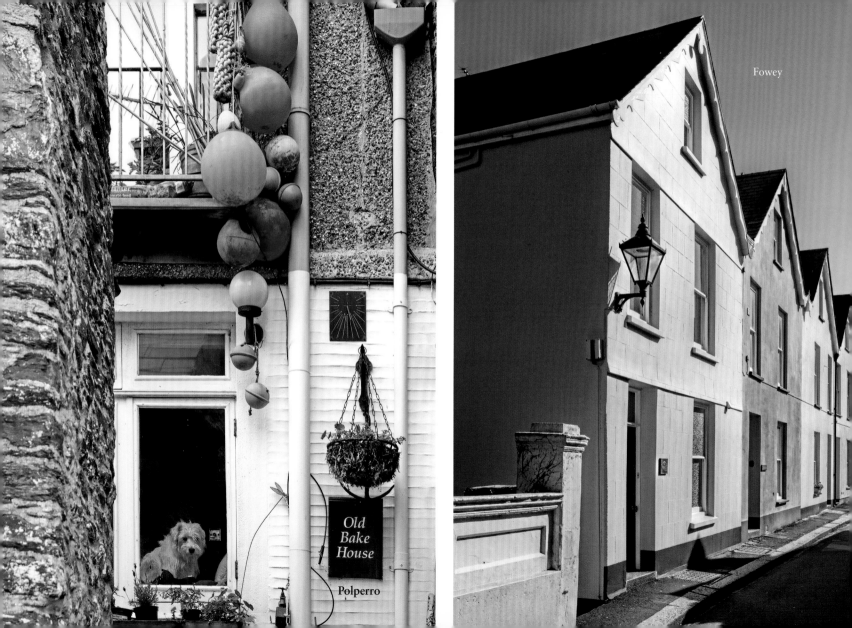

Old
Bake
House

Polperro

Fowey

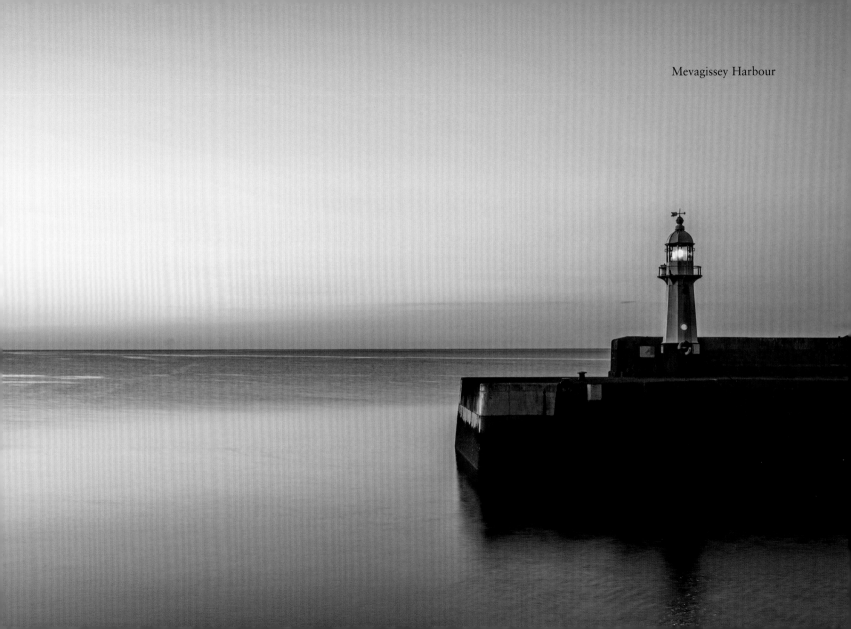

Mevagissey Harbour

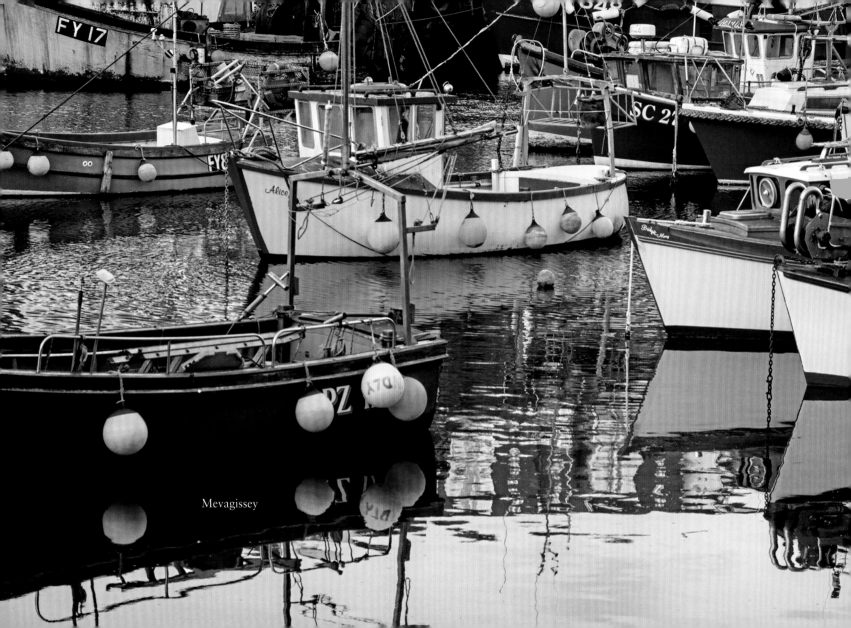

Mevagissey

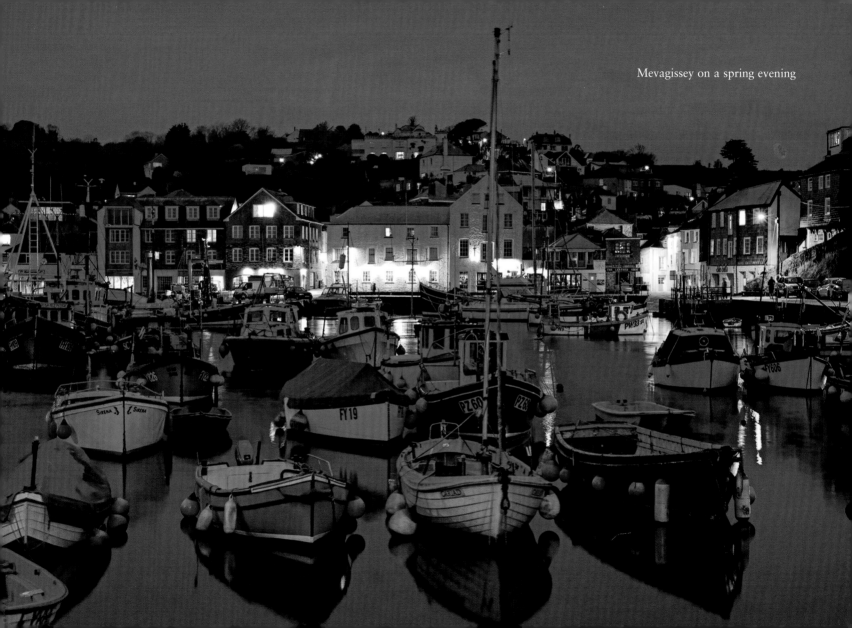

Mevagissey on a spring evening

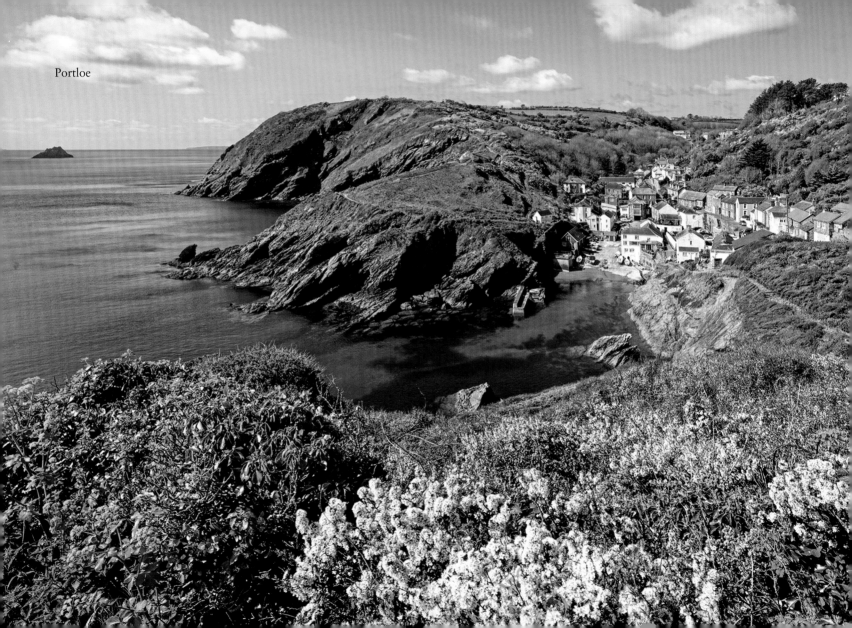

Portloe

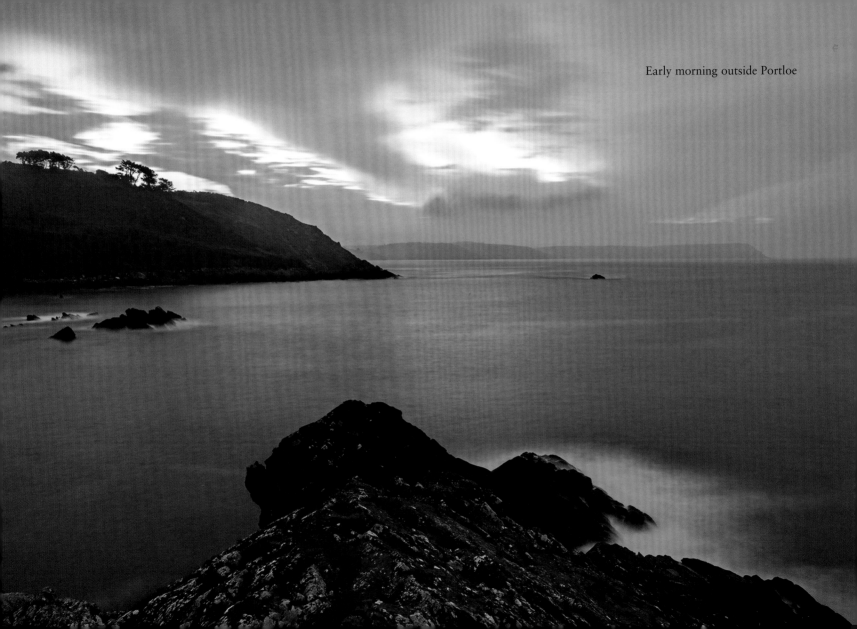

Early morning outside Portloe

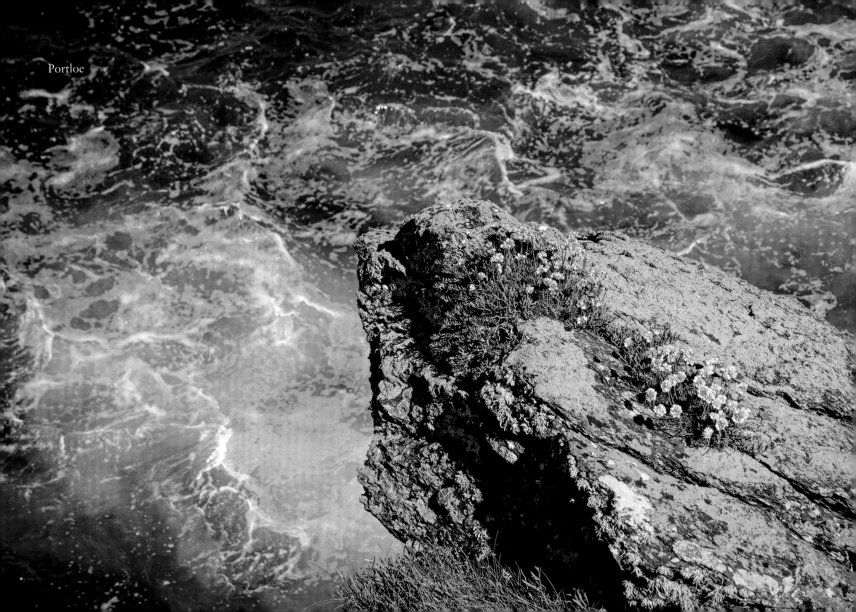
Portloe

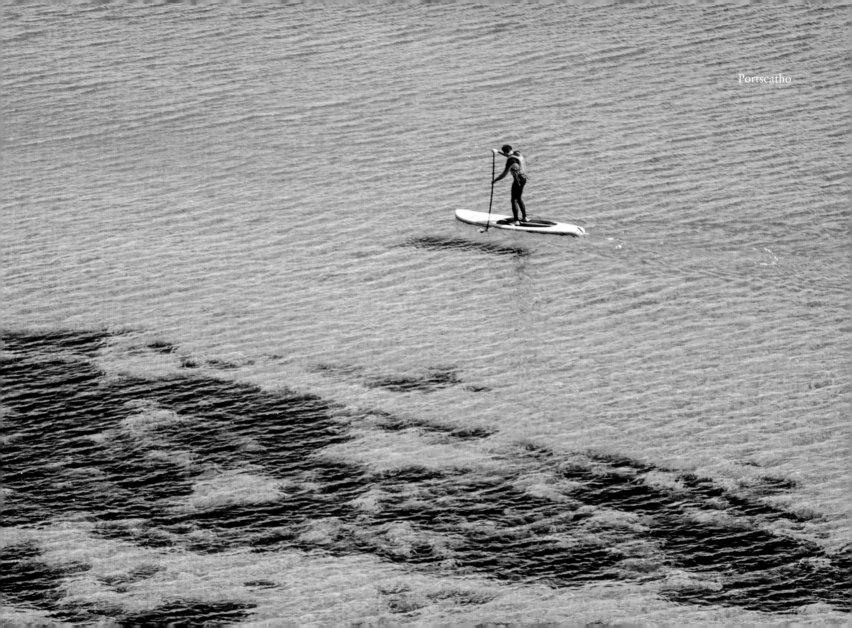

Portscatho

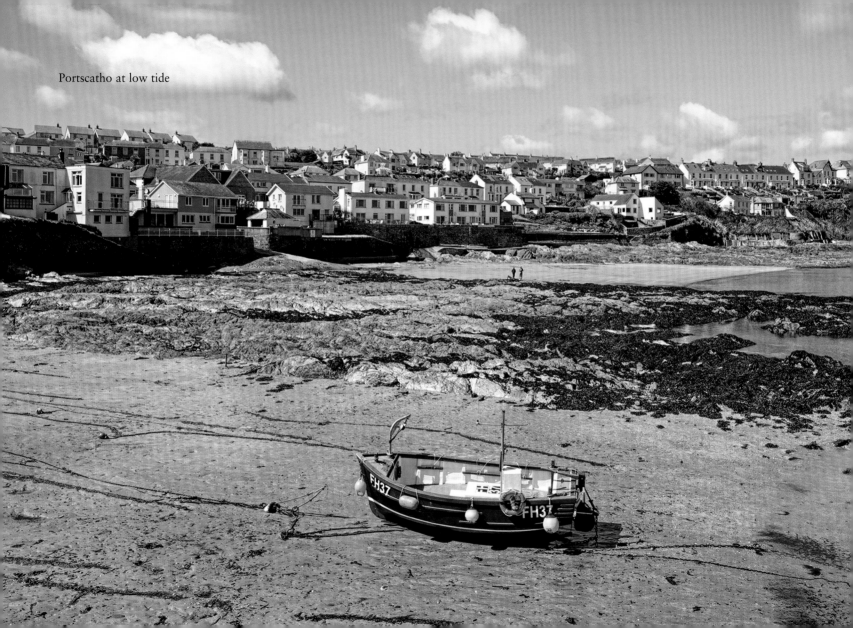

Portscatho at low tide

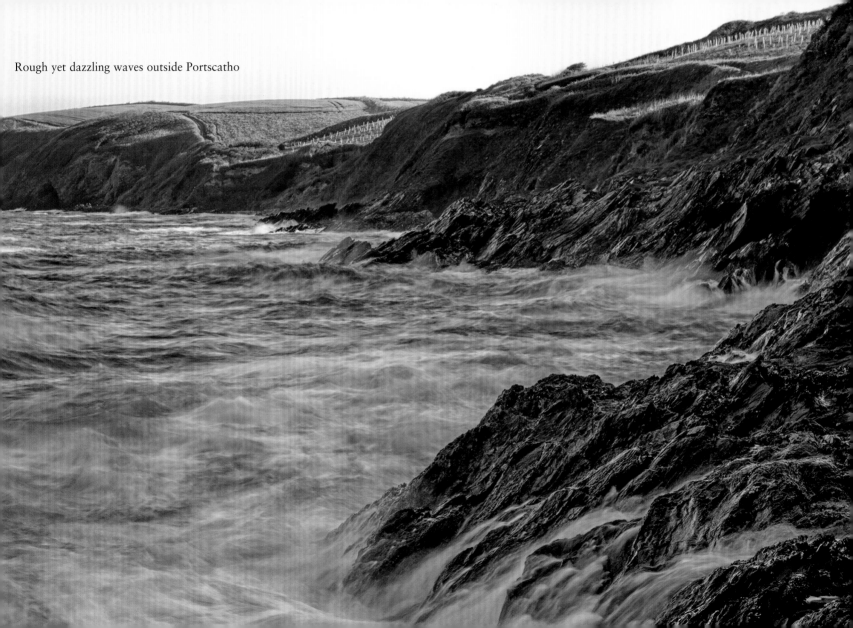

Rough yet dazzling waves outside Portscatho

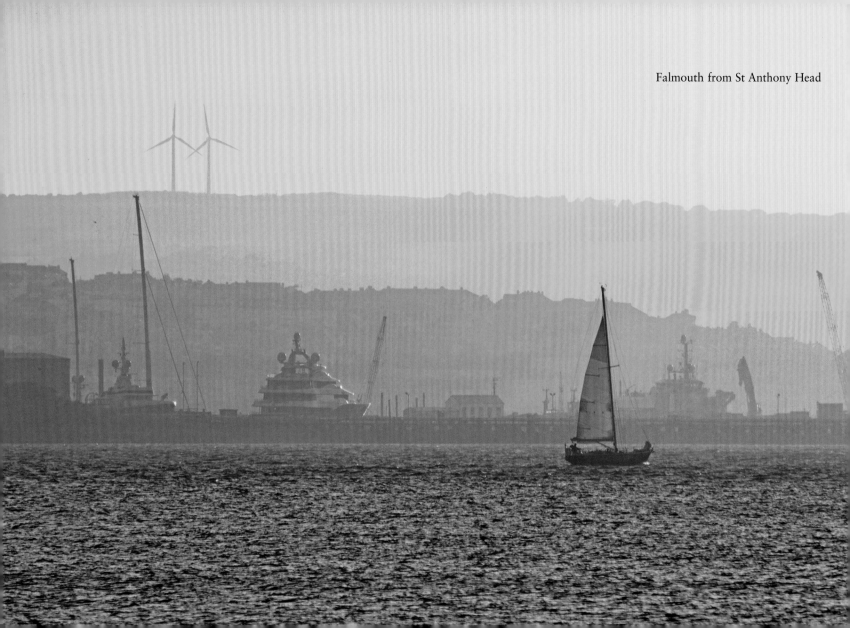

Falmouth from St Anthony Head

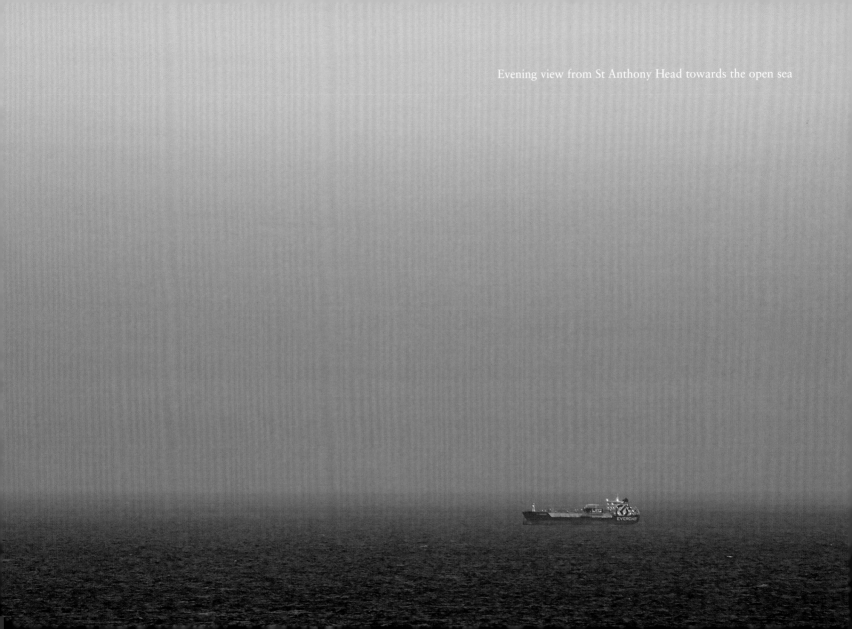

Evening view from St Anthony Head towards the open sea

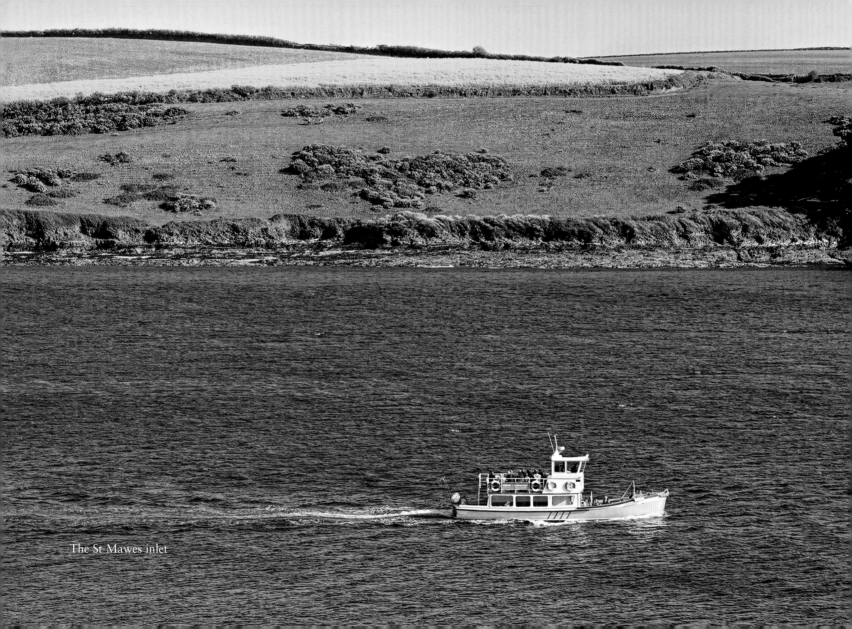

The St Mawes inlet

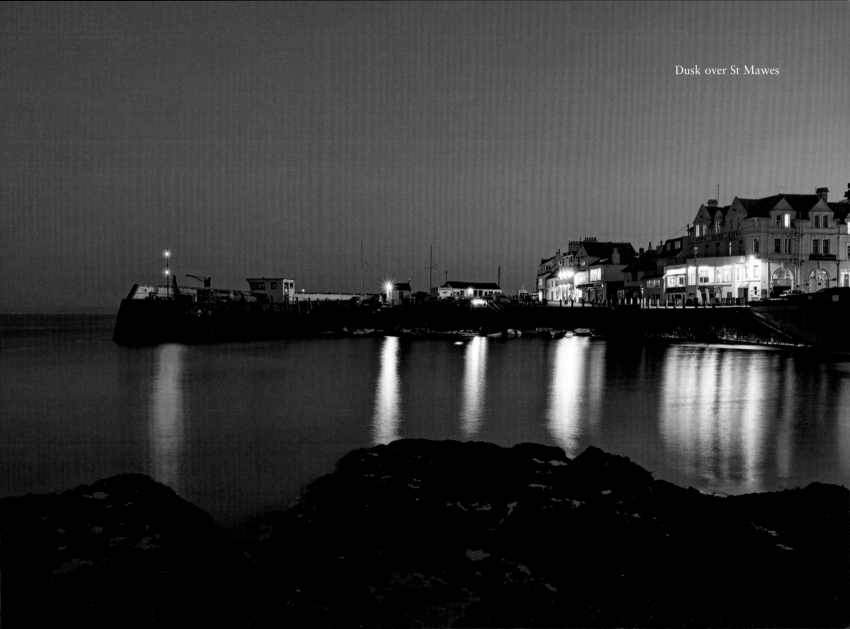

Dusk over St Mawes

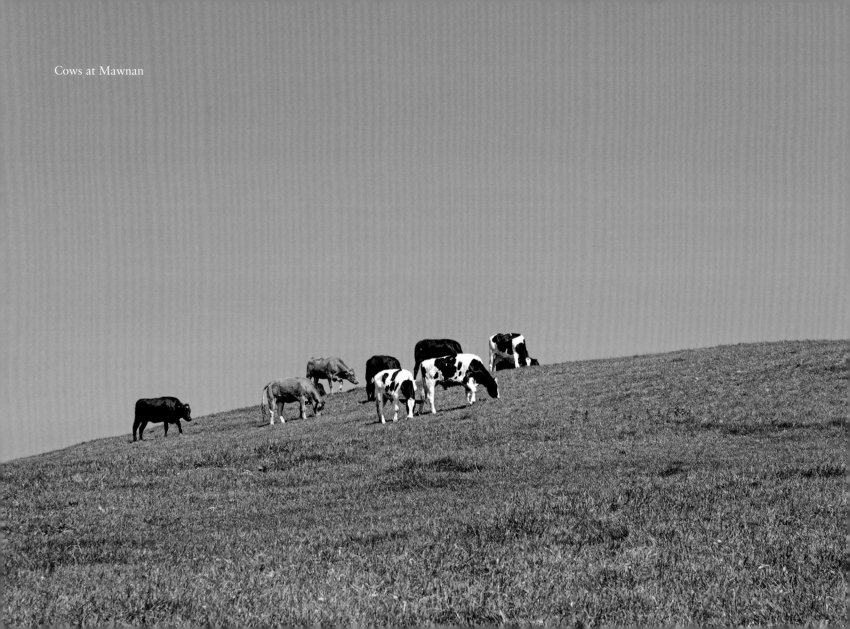

Cows at Mawnan

THE HINTERLAND AND GARDENS OF CORNWALL

Cornwall is renowned for its splendid coast with a variation of spectacular cliffs, fine-sand beaches, and charming villages. Having said that, the hinterland of Cornwall should not be overlooked. It is simply quite stunning how varied this part of Cornwall is, presenting windswept moors, lush forests and green fields, all in a landscape that can be anything from flat to quite hilly. There are also numerous gardens adding an astonishing plethora of flowers, colours, and beauty.

Furthermore, the Cornish hinterland houses numerous farms, cows and sheep, thus giving life and presence to it all. Never far from the sea, the incoming winds and seawater have an effect on the flora and fauna. It is even said that the quality of milk produced in Cornwall is richer thanks to the salty grass that the cows graze.

The look and feel of hinterland Cornwall give an impression of a classic and traditional England, often free from overcrowding. Consequently, the hinterland and gardens of Cornwall are a place for serene enjoyment.

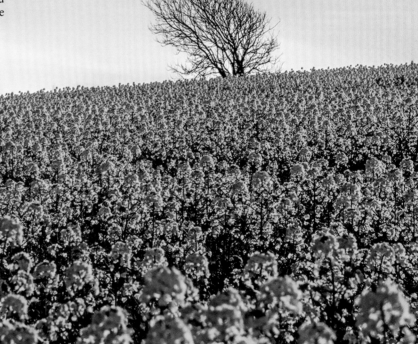

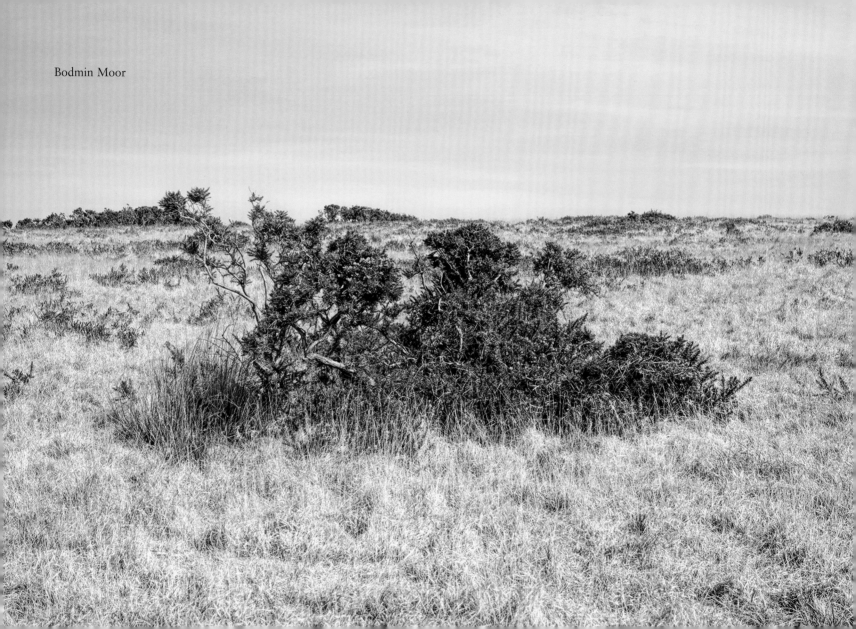

Bodmin Moor

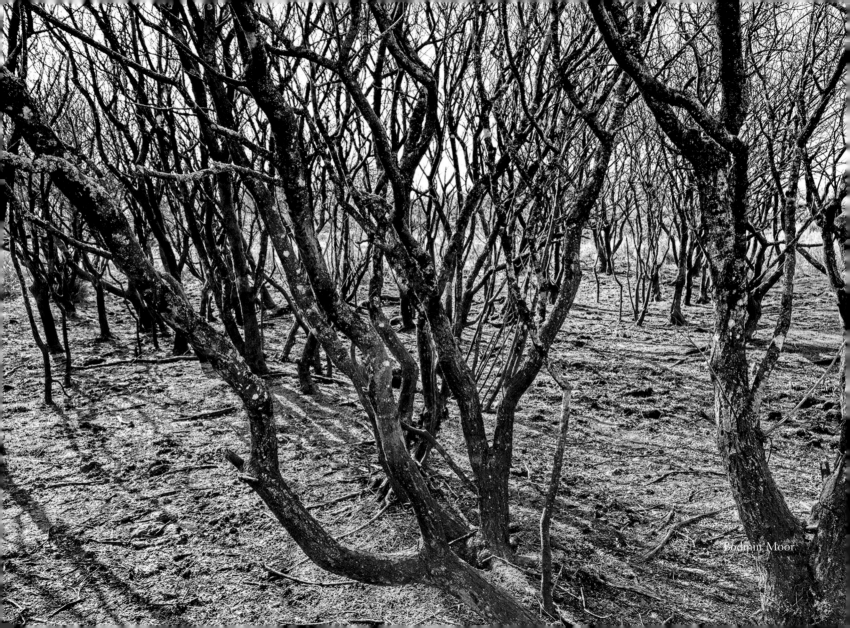

Bodmin Moor

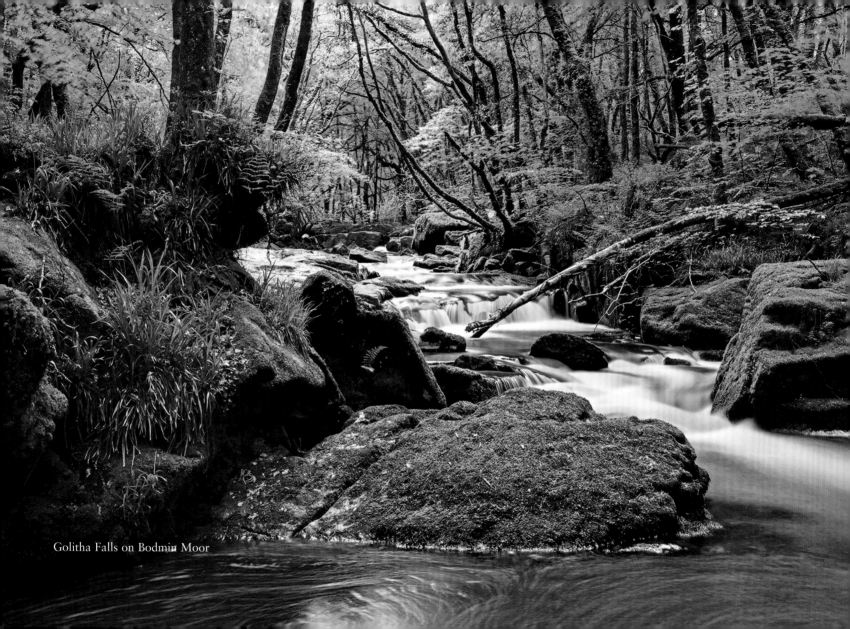
Golitha Falls on Bodmin Moor

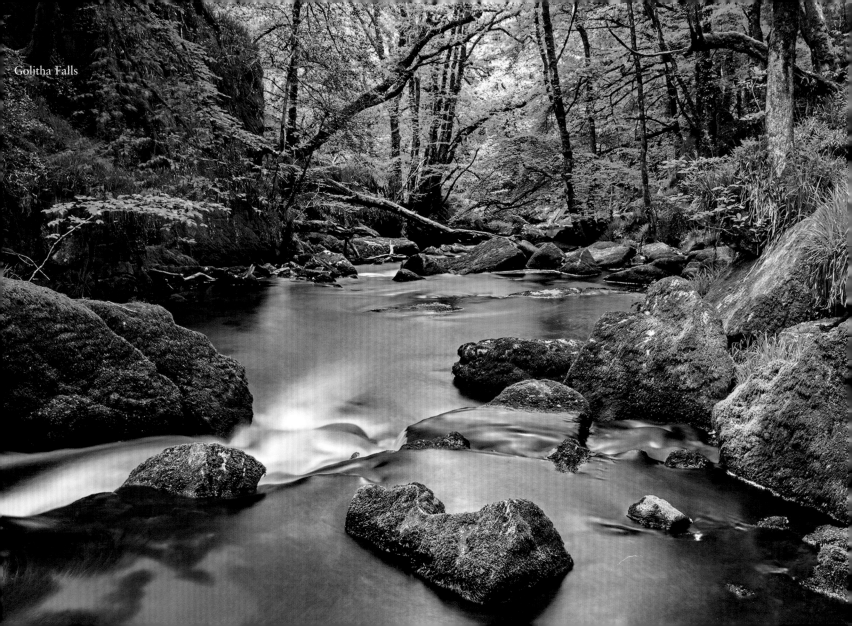

Golitha Falls

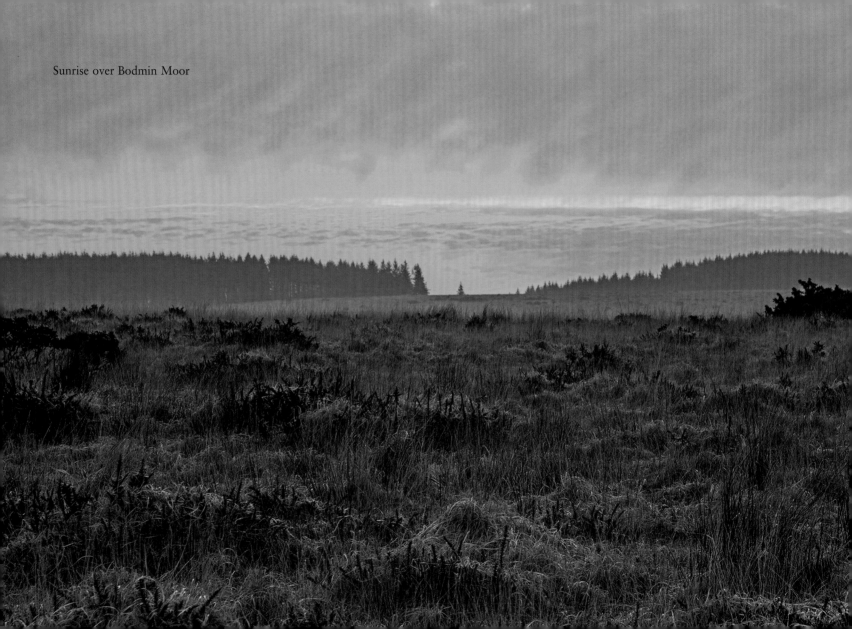

Sunrise over Bodmin Moor

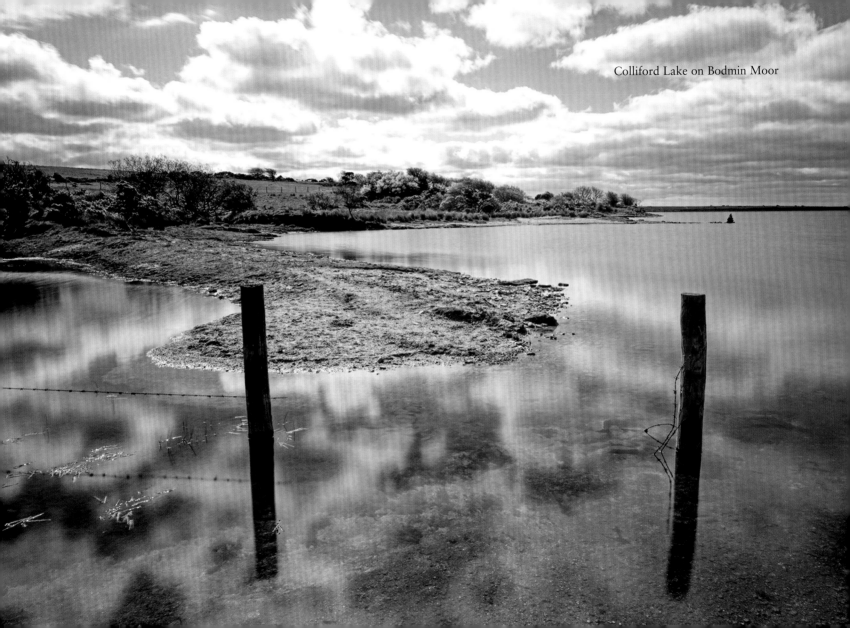

Colliford Lake on Bodmin Moor

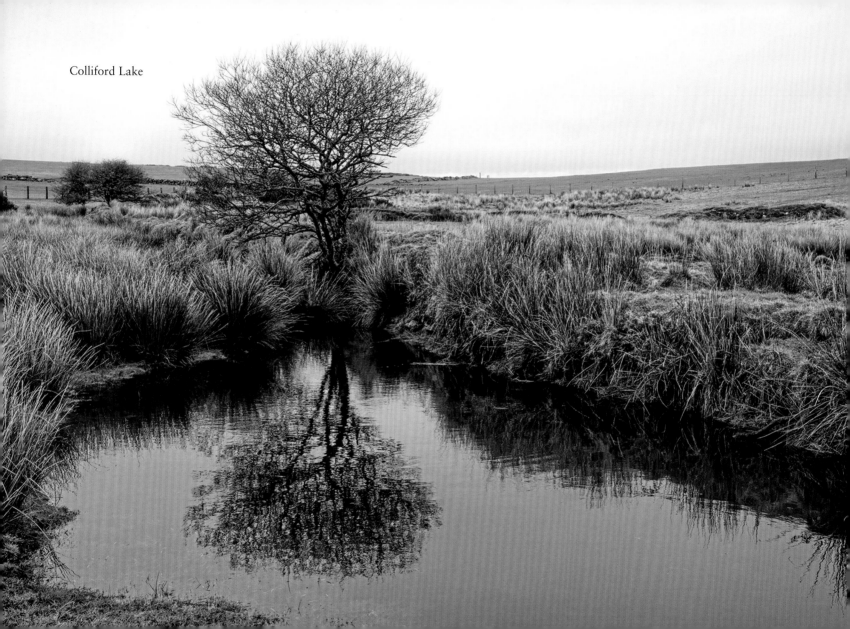

Colliford Lake

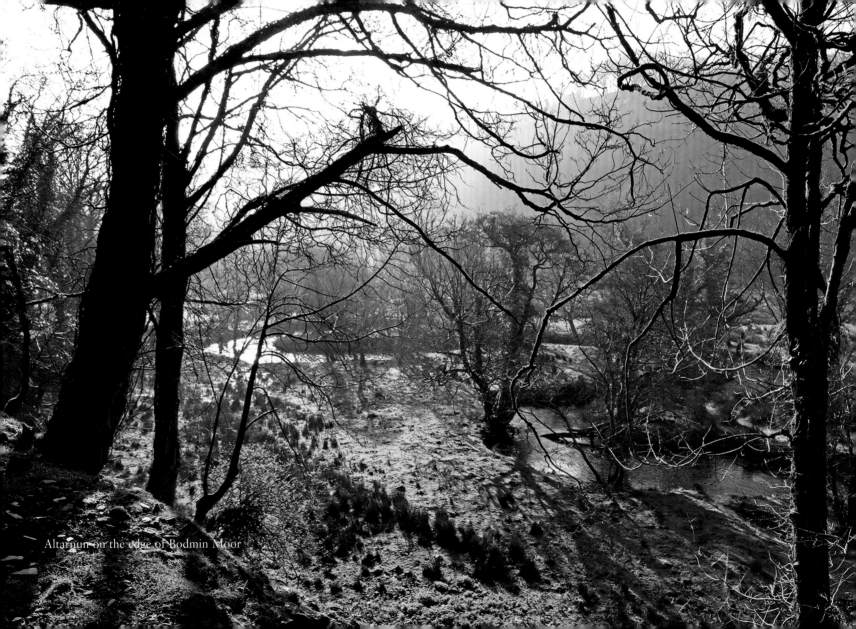

Altarnun on the edge of Bodmin Moor

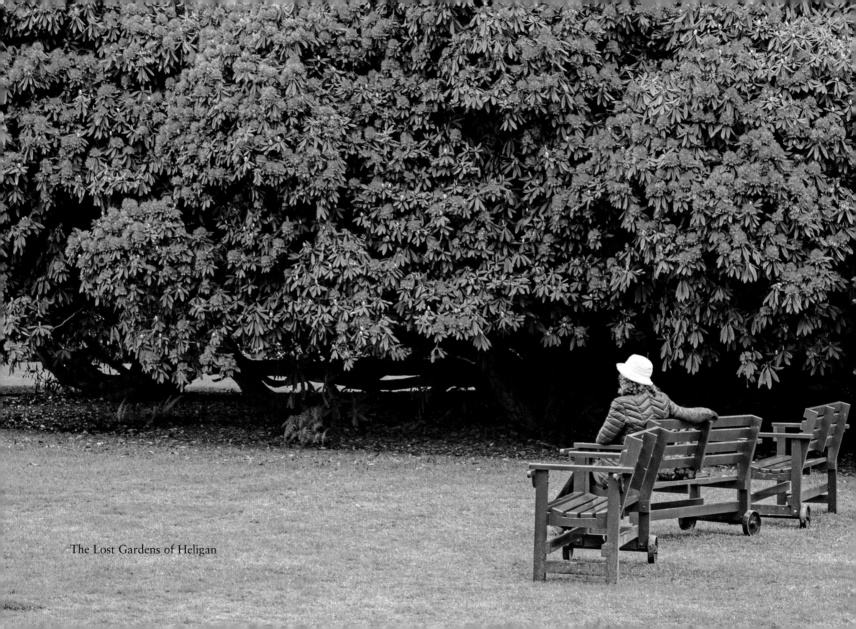

The Lost Gardens of Heligan

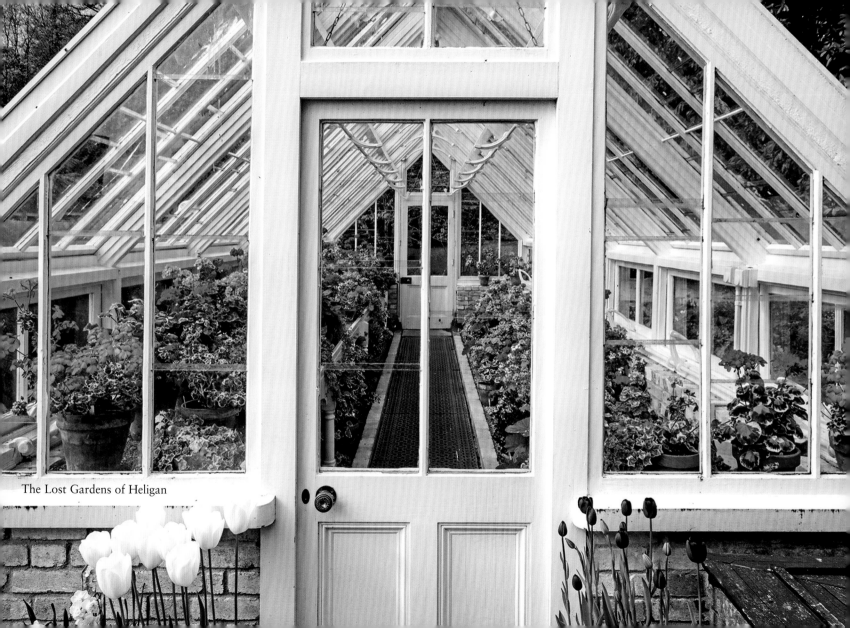

The Lost Gardens of Heligan

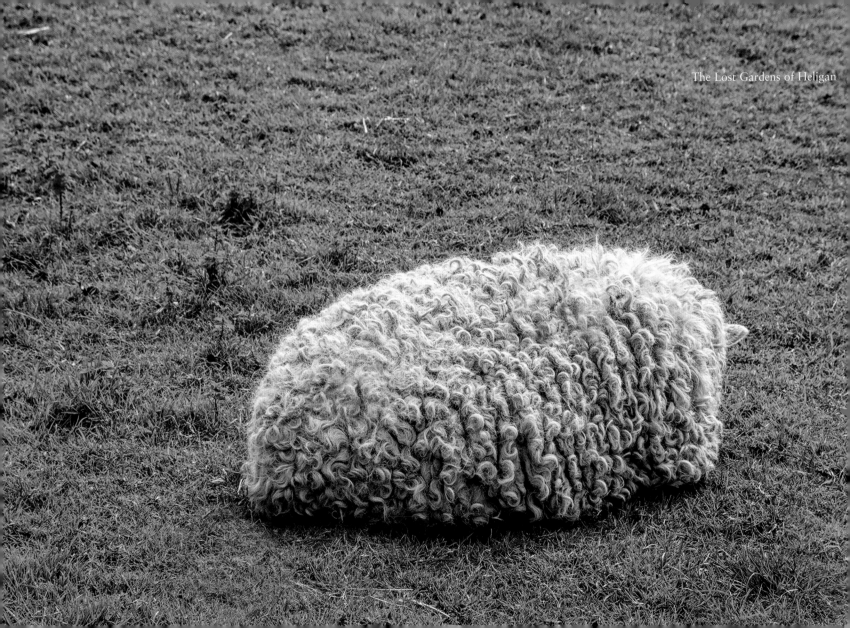

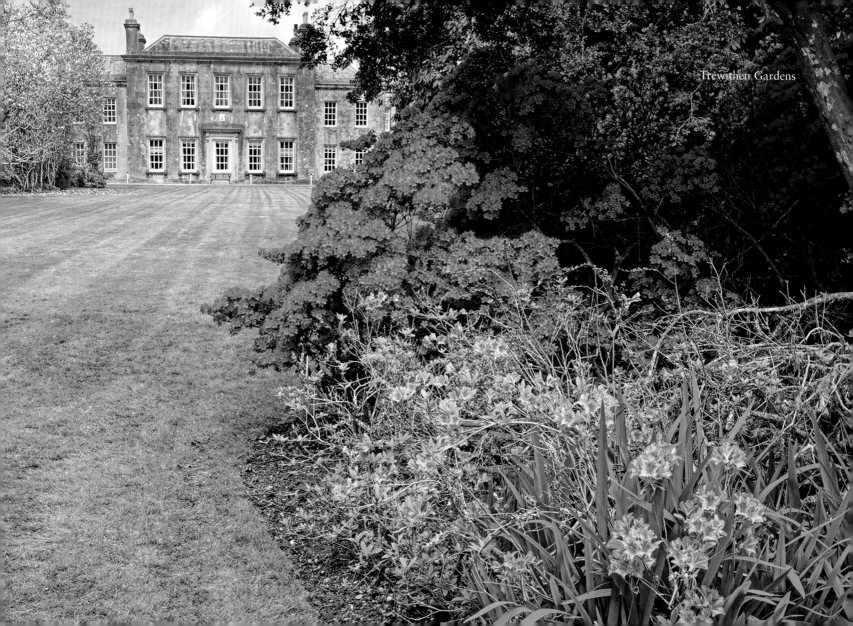

Trewithen Gardens

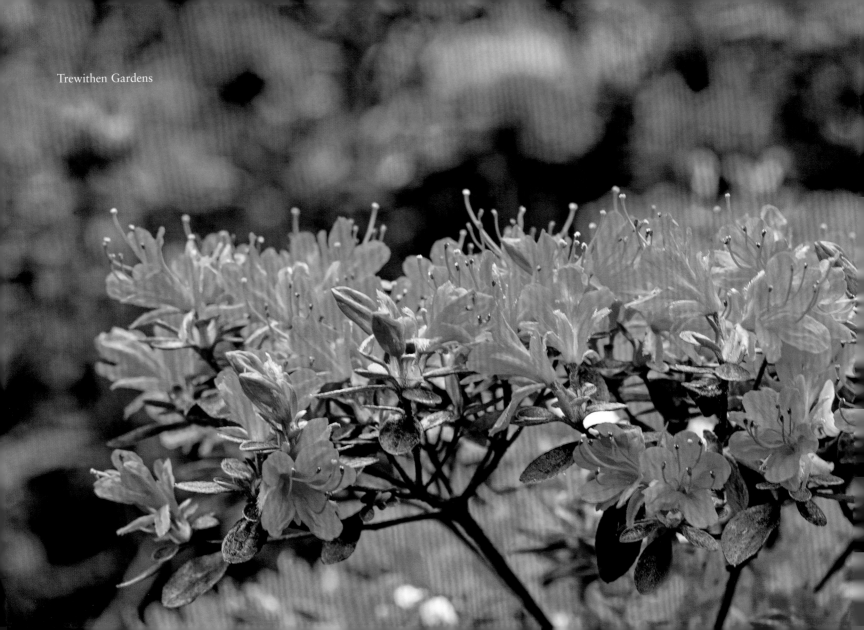

Trewithen Gardens

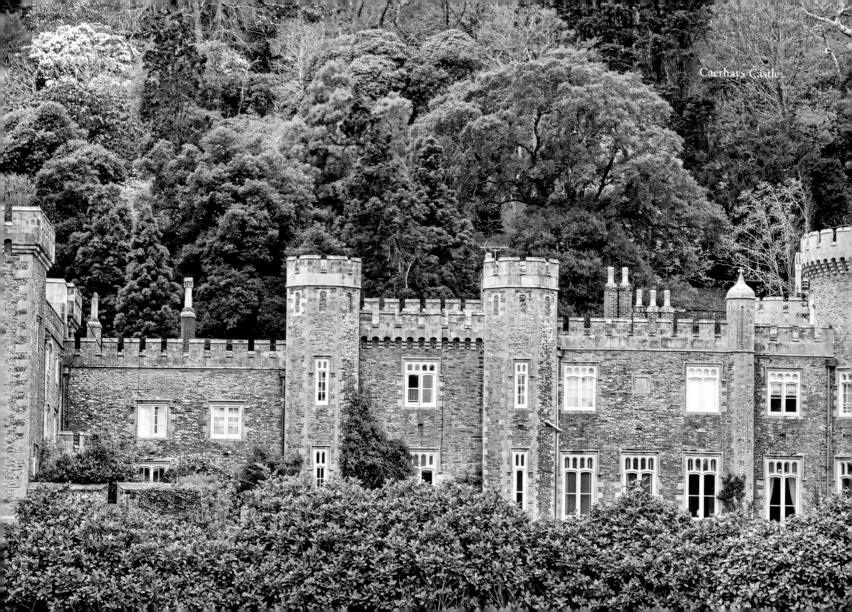

Caerhays Castle

Colour at Caerhays Castle

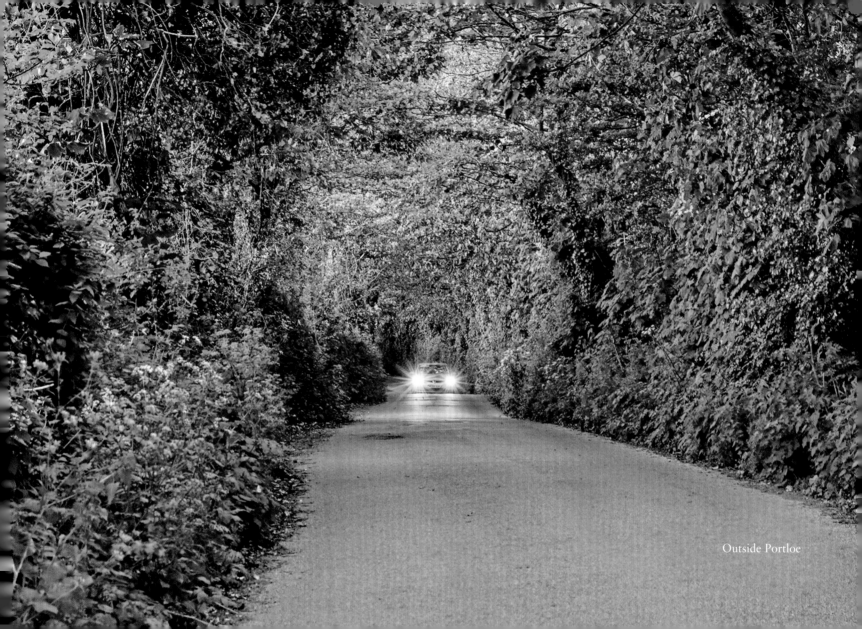

Outside Portloe

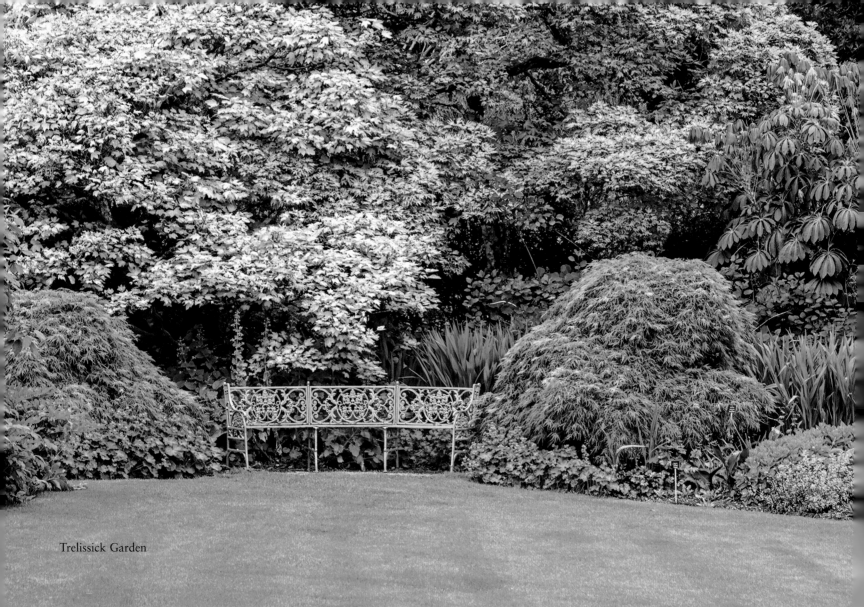

Trelissick Garden

Trelissick Garden

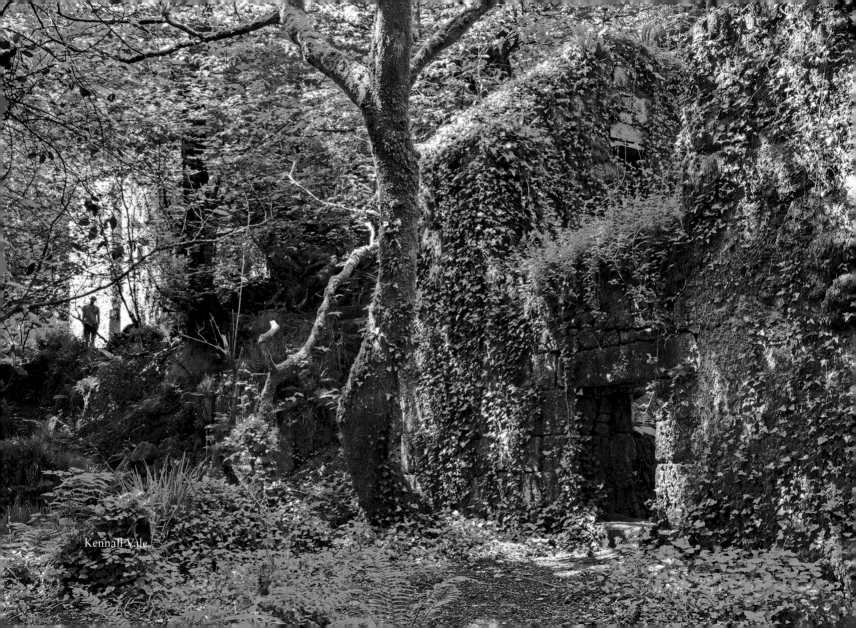

Kennall Vale

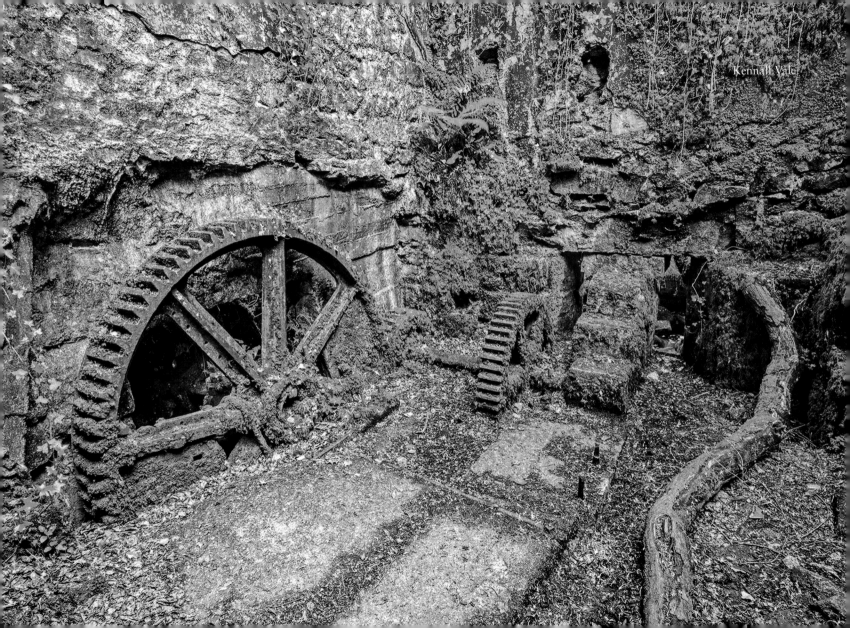

Kennall Vale

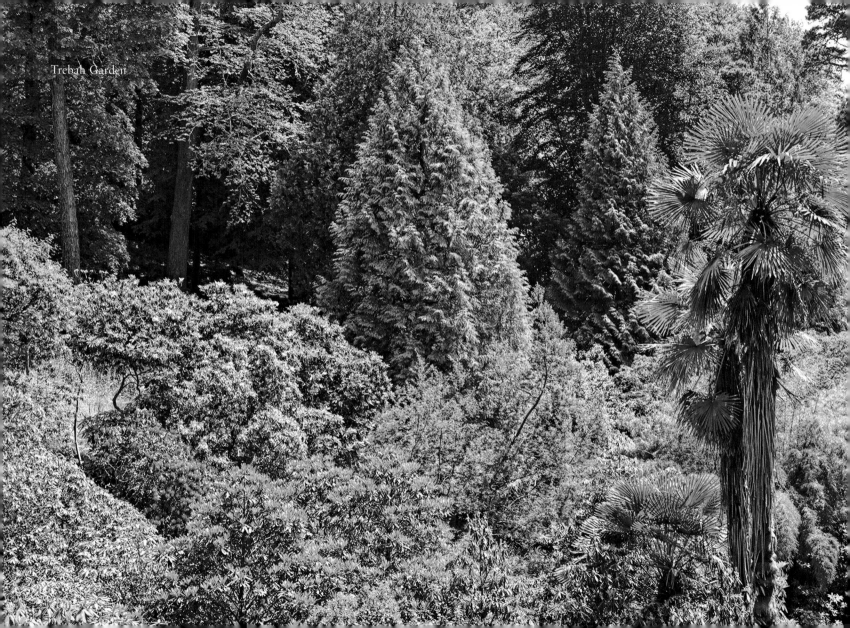

Trebah Garden

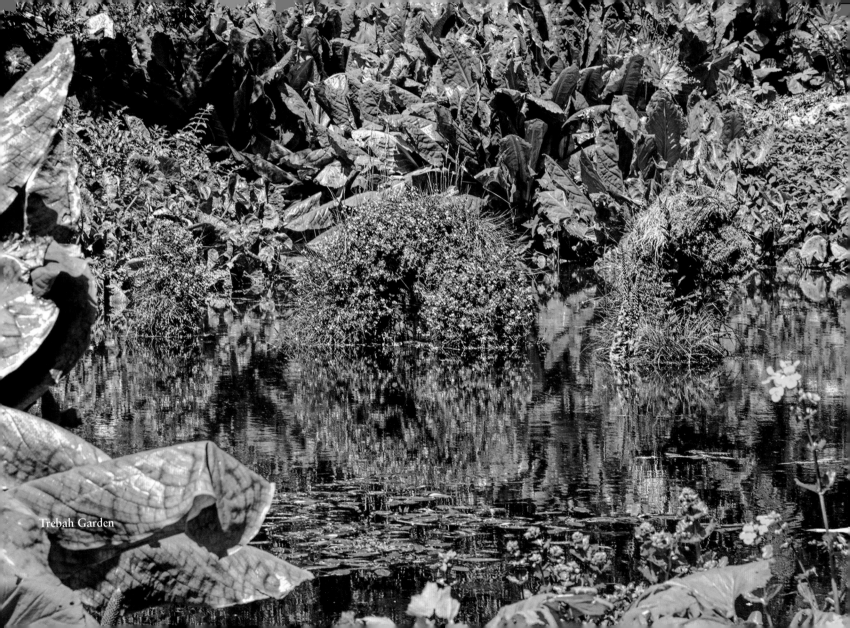

Trebah Garden

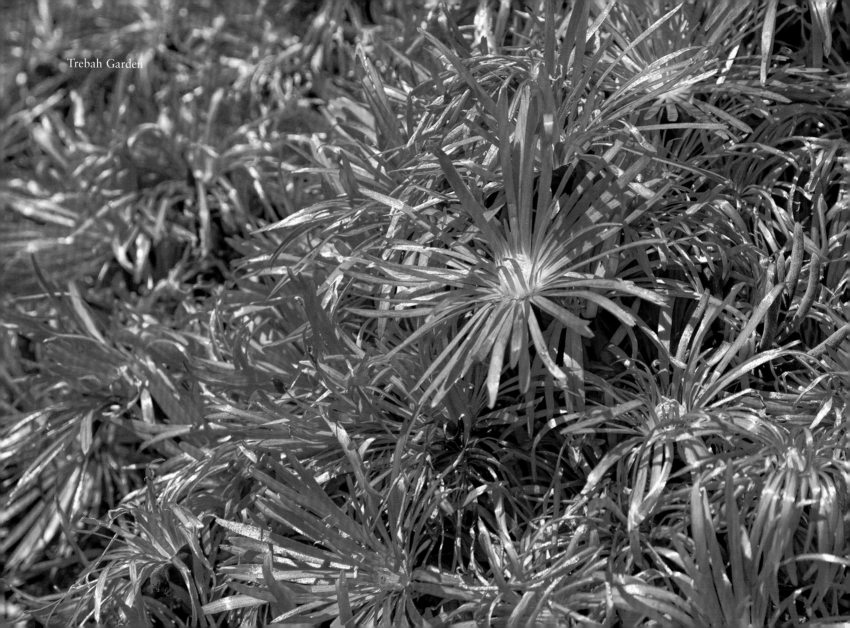

Trebah Garden

The Lizard Peninsula

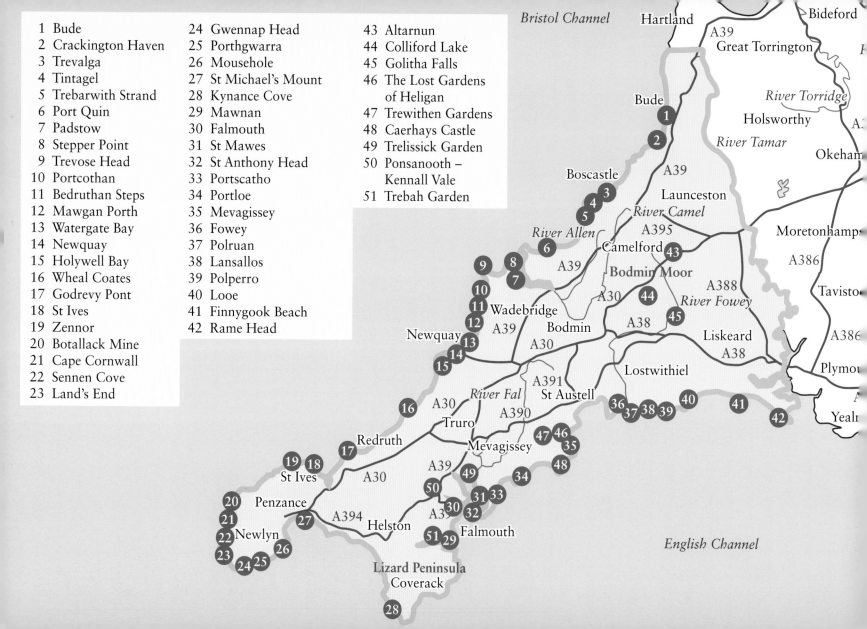

1 Bude
2 Crackington Haven
3 Trevalga
4 Tintagel
5 Trebarwith Strand
6 Port Quin
7 Padstow
8 Stepper Point
9 Trevose Head
10 Portcothan
11 Bedruthan Steps
12 Mawgan Porth
13 Watergate Bay
14 Newquay
15 Holywell Bay
16 Wheal Coates
17 Godrevy Pont
18 St Ives
19 Zennor
20 Botallack Mine
21 Cape Cornwall
22 Sennen Cove
23 Land's End
24 Gwennap Head
25 Porthgwarra
26 Mousehole
27 St Michael's Mount
28 Kynance Cove
29 Mawnan
30 Falmouth
31 St Mawes
32 St Anthony Head
33 Portscatho
34 Portloe
35 Mevagissey
36 Fowey
37 Polruan
38 Lansallos
39 Polperro
40 Looe
41 Finnygook Beach
42 Rame Head
43 Altarnun
44 Colliford Lake
45 Golitha Falls
46 The Lost Gardens
 of Heligan
47 Trewithen Gardens
48 Caerhays Castle
49 Trelissick Garden
50 Ponsanooth –
 Kennall Vale
51 Trebah Garden